GARDEN MAKER

CHRISTIE PURIFOY

HARVEST HOUSE PUBLISHERS
EUGENE, OREGON

For Jonathan

CONTENTS

INTRODUCTION . . . 7

1. **PREPARE** . . . 12
Dust to Dust / Cover Your Soil / Cosmos: The Best Thing About Poor Soil / Roses Part One: Dreams Really Do Come True / The (Almost) Instant Flower Garden

2. **DREAM** . . . 36
Garden Dreams and Designs / Garden Styles / Let There Be Light / Catalog of Dreams / Daffodil Songs

3. **SOW** . . . 60
Seeds: Ready, Set, Grow / Supplies for Growing Flowers from Seed / Plant a Zinnia, Plant Return / Wonder Flowers and Super Plants

4. **TEND** . . . 82
The Eternal Weed / The Care and Keeping of Gardens / Dahlia Trouble / Roses Part Two: All Hail the Queen

5. **CELEBRATE** . . . 106
Garden Parties / Elderflower "Champagne" / Peonies: Celebration and Commemoration / Flower Crowns / Lily Lanterns

6. **HARVEST** . . . 134
Flowers of Importance / My Easiest Bouquet Recipes / Superhero Shrubs / Self-Sowing Salvation

7. **MULTIPLY** . . . 156
Higher-Level Math / Loaves and Fishes / Love Returns / Fluff and Filler and Other VIPs

8. **ANTICIPATE** . . . 178
Story Maker / Putting the Garden to Bed / Tulips: The Now and the Not Yet

NEXT YEAR . . . 197
ABOUT THE AUTHOR . . . 203
BLACK BARN GARDEN CLUB . . . 204
ACKNOWLEDGMENTS . . . 207

INTRODUCTION

WHEN I WAS A CHILD, MY FATHER GREW FLOWERS.
He was raised on a family farm in Comanche, Texas, and had a very utilitarian approach to any plot of land—even our typical small-town backyard—and yet he primarily grew flowers. Our half-acre lot gave hot peppers, tomatoes, plums, and dewberries, but in my memory it's the canna lilies by the back fence that dominate the scene, like giants in a fairy world. They had slick tropical leaves and flaming-hot colors, and I did not really care for them. They seemed right at home in the heat and humidity I wanted only to escape. When I retreated to the air-conditioned chill inside our house, I found African violets on the windowsills and underneath the table lamps. They had soft, furry leaves and velvet petals and looked more like pets than plants. I would reach out to stroke them whenever I passed.

I also remember antique roses with wicked thorns collected in jam jars on the kitchen table. Strangely, I struggle to recall the flowers, but I can still see—and feel—those thorns. I once chased my pet bunny into one of

"Get up, my dear friend. . . . Look around you: Winter is over;
the winter rains are over, gone! Spring flowers are in blossom
all over. The whole world's a choir—and singing!"

SONG OF SOLOMON 2:12 MSG

my father's rosebushes, and the poor little rabbit made a terrible cry I had never heard before and have never forgotten. That image, pure white rabbit waiting for rescue beneath a bower of petals and thorns, is always there when I remember my father's garden. Bunnies munching neatly ordered lettuces belong to the pastel world of Beatrix Potter, but a white rabbit under a rosebush seems connected to older stories, mysterious and magical stories, like the fairy tales of Snow White or Briar Rose.

But *why* did my father grow flowers? Why do I grow flowers today? Why does anyone grow flowers? I planted my first flowers here at Maplehurst for purely practical reasons—or so I told myself. Flowers attract pollinators, and some flowers might even deter pests, so I planted zinnias to bring the bees toward my cucumber vine, and I planted marigolds to keep the tomatoes healthy. Cucumbers and tomatoes. The answer to why we grow these crops is easy: organic vitamins, homemade salsa. But flowers?

For me, the zinnias and marigolds were like the entrance to Alice's rabbit hole. Before I understood what was happening, I had dug out a jelly-bean patch of lawn and planted all the zinnias and marigolds that would not fit in the raised beds of my neat and orderly vegetable garden. In a sort of frenzy, I scattered an entire packet of cosmos seeds and buried five dahlia tubers. I planted two seeds of moonflower vine, and several (now deeply regretted) seeds of morning glory vine. That jelly-bean tangle has been replaced by a spacious formal flower garden with pea gravel paths and an Amish-built garden shed, but I am still pulling morning glories from my garden like weeds. I am still deeply in love with moonflowers and cosmos and dahlias.

I am in love. There really is no other answer. I am in love with flowers. In love with enchanting beauty and mysterious scents. In love with dewdrops on roses and the curling tendrils of sweet pea vines, and though these things may sound like sentiment and cliché, like images from a greeting

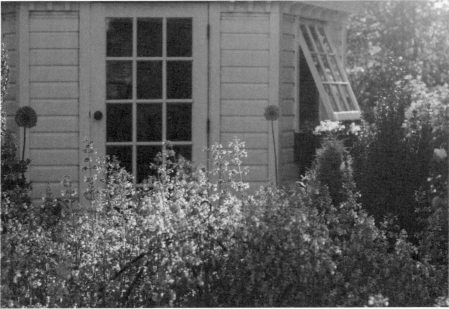

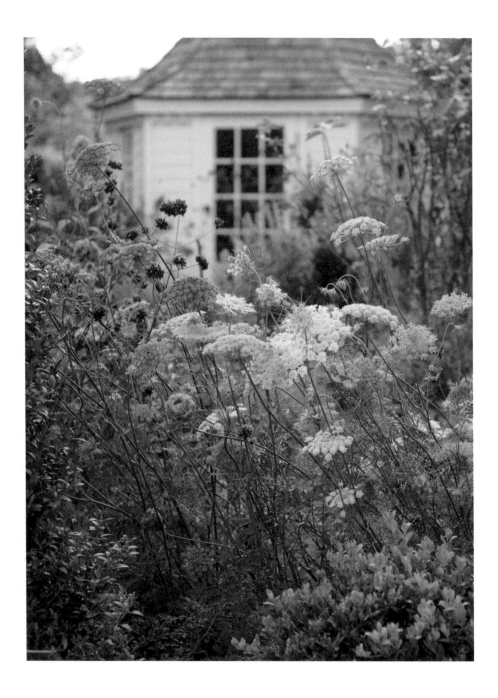

card, this love doesn't feel sweet or sentimental to me. Rather, it feels as if the roots of my very own life are now sunk deep in something ancient and powerful, something mysterious and precious. I grow flowers because I cannot help myself. I grow flowers as if some magician at the center of the universe has cast his spell on me, and I will never want my old unenchanted life back again.

In my flower garden, I am the weaver of stories. In my flower garden, I am the composer of seasonal songs. Or maybe I am more conductor than composer. This garden of mine is certainly singing a song, but the song delights me, moves me, and surprises me. I may have tended it, but I have not created it. The source of this music is outside myself. I cannot recommend flower gardening for the sober minded. I cannot recommend it for those afraid of mysterious rabbit holes, who prefer to keep their two feet fixed firmly to a clean and solid and entirely predictable floor. I cannot, in good conscience, recommend intoxicating moonflowers or romantic roses to anyone who values utility and efficiency and productivity above all. But for those who read fairy tales or cry at arias, for those who suspect that heaven lies just behind the veil of this everyday world, well, to those I say:

Welcome to the garden. Welcome to this holy work. I understand if you are afraid. The thorns are knife-sharp, and the weeds are always waging their quiet wars. But here is the promise that has been made to each one of us: "Those who sow with tears will reap with songs of joy" (Psalm 126:5). Every garden is singing a song for the One who made us, and we are invited to sing along.

1

PREPARE

DUST TO DUST

FLOWER GARDENS DON'T BEGIN WITH FLOWERS.
They don't even begin with seeds. They begin with desire and vision, and
they begin with ordinary dirt. Of course, most gardeners never use the
word *dirt*. They speak of *soil*, and they speak of it with a connoisseur's
finely nuanced vocabulary. The poet-gardeners talk of loam, clay, sand,
gravel, humus, and marl. The scientist-gardeners mention lime, phospho-
rus, nitrogen, and acidity, and they fiddle around with test tubes and color
strips. I probably do not need to tell you that I love the litany of earthy gar-
den words, and I have never scooped soil into a test tube. All are welcome
in the garden, and there are no garden police to force test tubes on you if
you do not want them.

*"It feels like the end of something, but there is also the sense of a
beginning, the opening of a new phase in the life of the garden . . .
when the mixture of compost and manure . . . begins its long process
of rotting down and enriching the soil. All year the box clippings and
the vegetable haulm, the dead heads of spring bulbs and summer
flowers, last autumn's leaves and this year's grass, have been layering
down into a rich dark crumbly cake from which next year's plants
will emerge nourished and stronger. In our end is our beginning."*

KATHERINE SWIFT, *THE MORVILLE HOURS*

15

Whether you lean toward poetry or science, your first task is the same: Cast your eyes over your bit of earth and run it through your fingers. When you grab a handful of soil after a summer rain, does it ball up like a bit of potter's clay? Is it already dry like sand in a child's pail? Is it crumbly and black like something sweet from Grandmother's cake pan? Roses will appreciate the sticky clay that holds on to nutrients and water. Yarrow and cosmos will be happy in the quick-drying, nutrient-poor sand. Just about every flower will love chocolaty loam. If your eyes are already glazing over, if this already sounds like too much technical detail for you, take a deep breath and dig in. Garden rules are only guides, and there is an exception to every rule. It is true that roses love heavy clay, but rugosa roses love sandy soil near a salt-sprayed beach. Take a look at the flowers growing so well in your neighbor's garden, then give them a try in your own. You will get to know your soil over time. You might even create your own language to describe it.

There is also no need to learn the technical terms printed in minuscule type on bottles and bags. I recommend avoiding chemical fertilizers. It is best to feed your soil rather than your plants. Step away from the sprays with pictures of angry bugs. If you care for the source—the soil—your garden will shrug off pests and grow. Feed your flower beds autumn leaves you've chopped up with the lawn mower. Feed your garden black compost from your backyard pile. Layer cardboard over the worst of the weeds and cover it with aged manure you've brought home from the garden center. I live in mushroom-farming country, and every winter I shovel out truckloads of the steamy, stinky soil that remains after the mushrooms are picked. If left to sit and cool off for a few months, mushroom compost is just the thing for hungry flowers. Perhaps you have pine needles in abundance or

a friend with a chicken coop or rabbit hutch. There is science behind every choice, but even the poets intuitively know that the earth requires a steady diet of rot and decay if it is to continually erupt with new life.

In "The Burial of the Dead," the poet T.S. Eliot reminds us of this difficult truth: "April is the cruellest month, breeding / Lilacs out of the dead land, mixing / Memory and desire." Past and future meet and mingle in the ground of a garden. What died and was left to lie on your soil last year? What form of new flowering life do you hope will grow next spring? Gardens grow because death can be fruitful and resurrection is real. A garden maker may recite no formal creeds, but she lives them. Everything I practice in the garden says, *I believe, and I look forward to the resurrection of the dead and the life of the world to come.* What is true in the garden is true in the whole earth. What is true in the stem of a flower is true in our own arms and legs. Do you want to live? The same voice that spoke green things into existence spoke in the accent of Nazareth, promising that if we lose our lives, we will find them. Christ is our perfect gardener, and He bids us come and die. It is a loving invitation.

How then to prepare? How do we make gardens and how do we tend our souls? We do not run away from suffering and death but receive them. We water the ground with our tears. We spread dark death (mushy leaves, rotted manure, shredded branches from a local tree trimming company), and we reap new life. We layer on the old (brown cardboard, pine needles, grass clippings) and trust that deep down, in the dark and the wet, earthworms are tunneling and webs of mysterious fungi are spreading and all of it—however dirty, stinking, and gross—is also beautiful, true, and good.

And so very much alive.

COVER YOUR SOIL

The earth is happiest with a blanket. If it isn't already hidden beneath green, growing things or sweetly rotting leaves, we gardeners can help do the job. Here are some cover materials to consider:

— *brown cardboard*

— *newsprint (avoid glossy, colored pages)*

— *homemade compost*

— *store-bought compost*

— *mushroom compost (also called mushroom mulch or mushroom soil)*

— *aged manure from cattle, horses, and chickens (fresh or aged if from rabbits)*

— *weed-free straw*

— *pine needles (but only if you have an abundance—pine tree roots need their own pine needle blanket)*

— *shredded leaves from deciduous trees*

— *shredded bark (especially good if green leaves have been shredded too)*

— *grass clippings*

My advice? Never bag your leaves in the fall. Instead, chop them up with a lawn mower and spread the resulting leaf crumble as a mulch on your garden. The only ones who will be sad about this are the children. Perhaps we can leave them one pile for jumping.

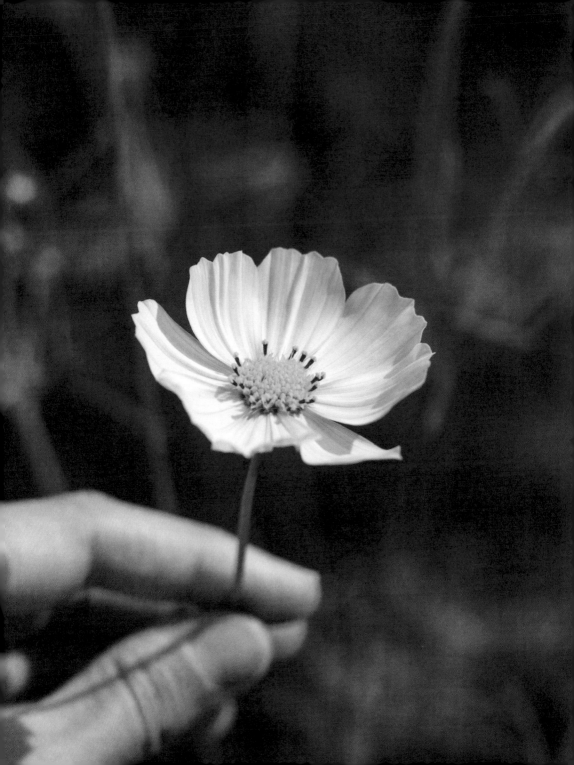

COSMOS

The Best Thing About Poor Soil

COSMOS ARE SOME OF THE EASIEST AND MOST satisfying flowers to grow, but I still found a way to ruin them. Just as we can kill a houseplant with overwatering, we can kill a flower with too much feeding. Shovel still-hot manure from your neighbor's horse barn around the base of your roses, and you might just burn them to death. Spread a thick layer of steamy mushroom compost over cardboard for your first flower garden, and the cosmos you try to grow that spring will not thank you for that super-rich meal. The lily bulbs loved their hot and stinky soil, but the cosmos grew tall and green and monstrous and never flowered at all. They were mutant cosmos, and I finally had to pull them all out before they suffocated the rosebushes with their rampant soft-green growth.

Four years later, the soil in my flower garden is much poorer. That initial blanket of mushroom compost has nurtured life cycle after life cycle, and its strength is fading. I'll need to feed the garden well with fresh compost next winter or spring if I want to keep the roses happy, but meanwhile I decided to give cosmos one more chance in my garden. This year, instead of green monsters, I have what I always wanted—delicate, open-faced flowers that

"How agitated I am when I am in the garden, and how happy I am to be so agitated. How vexed I often am when I am in the garden, and how happy I am to be so vexed."

JAMAICA KINKAID, *MY GARDEN (BOOK)*

23

dance in the slightest breeze and offer abundant and accessible pollen to every bee.

My experience with cosmos highlights one of the most important components in garden making: time. Time is like sunshine—necessary but without moral value. If we have a great deal of sunshine, we grow sunflowers; if we have only a little, we grow astilbe. If we will be gardening over years, we can smother the grass with cardboard, cover the cardboard with rich compost, and observe which flowers are happiest year after year. If time feels lacking, if we want perfect flowers this year, or if we long to turn our pink hydrangeas blue, we will fiddle around with test tubes and measure out precise servings of lime or potash or mycorrhizal fungi. There is no single right way. There is only you and your soil and the kind of tending that brings you joy.

This year, deadheading the cosmos is bringing me joy. Deadheading is the practice of snipping off spent blooms before they set seed and sap the plant's strength. Without deadheading, cosmos will grow and flower and then fade away fairly quickly. If you cut off the dying flowers, the plant will keep flowering and flowering because it wants so much to make seeds. Of course, if deadheading sounds like a hassle and a chore, simply rename it *cutting flowers for the house*, and the result will be the same—more flowers. In the mathematics of gardening, the subtraction of deadheading and pruning almost always equals the addition of beautiful flowers.

Cosmos are an annual, which means they will complete their life cycle in one year. However, the seeds that fall in my garden in late summer often sprout the following spring. I especially love the simple white flowers of 'Purity', but I am also wowed by the candy stripes on 'Velouette'. The ruffles of 'Cupcake' and 'Seashell' look amazing on the seed packet but are somehow much less impressive in the garden. The simplicity of cosmos

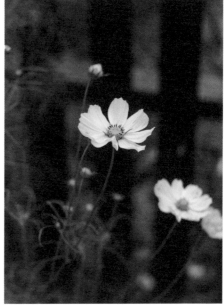

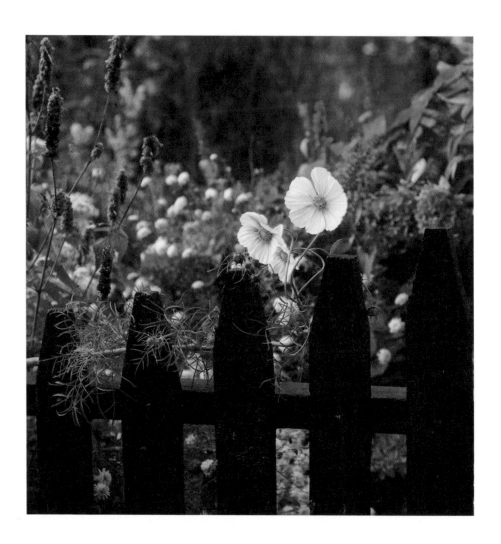

is their strength. Why turn these delicate beauties into fussy fluffballs? Unfussy cosmos are just right for the unfussy gardener. If I've neglected my soil, if I never got around to spreading compost or laying down a heavy blanket of chipped bark mulch, then the cosmos will do well. They are a special gift for the gardener who tired of shoveling manure and sat on the porch with a glass of iced tea. They are the prize for not finishing your garden to-do list. Cosmos don't even want too much water. Rainfall is probably more than enough.

Cosmos are proof that gardeners with little to give their gardens won't receive less in return, only different.

COMMON NAME: *cosmos* | **SCIENTIFIC NAME:** *Cosmos*

MY FAVORITES: *'Purity', 'Daydream', 'Sensation', and 'Velouette'*

REASONS TO LOVE COSMOS: *Poor, dry soil doesn't faze them.*

REMEMBER: *From cornflowers and cosmos to snapdragons and zinnias, many flowers respond well to deadheading, but take note that not all flowers will rebloom and too-thorough deadheading, especially at the end of the summer, means no seeds to save, no colorful autumn rose hips (the vitamin C-packed fruit of many rosebushes), and no self-sown flowers popping up in the garden next year.*

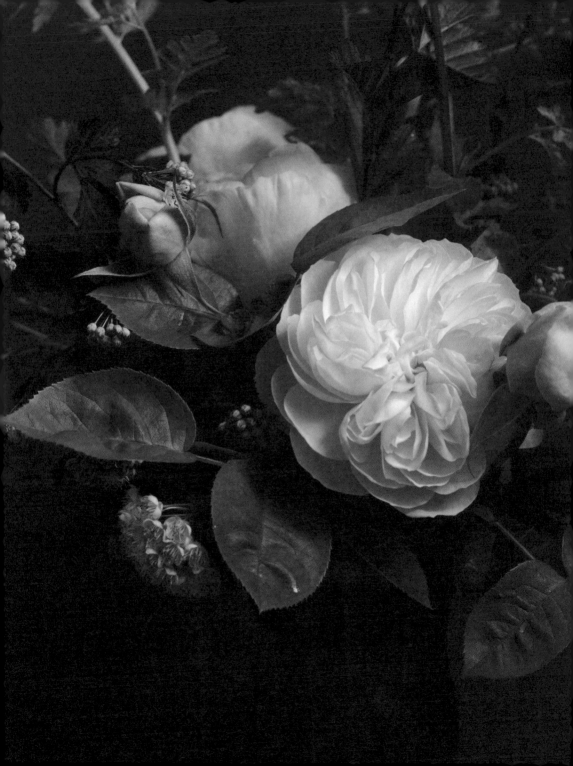

ROSES PART ONE

Dreams Really Do Come True

IF MY AIM IS TO ENCOURAGE THE UNINITIATED to take up flower gardening, why on earth would I begin this book with a difficult flower like the rose? Annual flowers like cosmos, sunflowers, zinnias, and marigolds offer so much color and life for so little effort. They belong to Garden Making 101. Aren't roses best left to the experts? To which I answer, "Why should the experts have all the fun?" Yet if I am being ruthlessly honest, I will admit that roses are not fun. Easy, colorful zinnias are fun, but roses are something else. They are the stuff of dreams and garden visions. They are intoxicating, fascinating, enchanting. Roses cast a spell no other flower can quite manage, and if we are unsure about digging up the grass, if we are nervous about our own abilities or hesitant to spend the money or the time, no flower can propel us past our doubts like the rose.

I began to make flower gardens because the catalog from which I chose my vegetable seeds included a small selection of roses. While I studied descriptions of tomatoes and green beans, my eyes kept straying toward those pages where the catalog copy emphasized not flavor, but color and scent and petal count. I felt utterly inadequate to grow those enigmatic flowers, but the desire they stirred up was stronger than my many fears.

———————|———————

"The air of June is velvet with her scent,
The realm of June is splendid with her state."

VITA SACKVILLE-WEST, "THE ROSE"

And what did I desire? I wanted to know exactly what the writers meant when they said a rose smelled of "myrrh." I wanted to see for myself why the leaves of the rugged rugosa roses were described as gray-green, and I wanted to travel back in time with the 'Apothecary's Rose' once grown by medieval monks. Its blood-red petals were said to symbolize the Christian martyrs and were rolled into the prayer beads we still call a "rosary."

Within the white picket fence of our vegetable garden, I planted 'Brandywine' tomatoes and the green beans called 'Slenderette', but outside the fence, I planted a bright pink winter-hardy climbing rose called 'William Baffin'; over the arbor gate, I planted a 'New Dawn' climber the color of a pink seashell. I planted a bed of roses in front of the old lilac that anchored one corner of the garden—pale pink 'Bonica', three small 'Fairy' roses in a deeper pink, and the highly scented hybrid rugosa rose 'Blanc Double de Coubert'. Of course, I made mistakes. The 'New Dawn' was really much too vigorous for the arbor, and the pink of the 'William Baffin' was so vivid it made me want to shield my eyes, but even in the mistakes I learned something incredibly important: *Roses don't have to be difficult.*

We can make them difficult. We can subject them to too much shade and decline to give them our richest soil. We can choose fussy varieties that will refuse to stay healthy without poisonous sprays. We can demand perfection and weep over every yellowing leaf or bug-eaten petal. We can shake our fist at the sky when heavy rain shatters the flowers. Or we can look at them as they ask to be seen—as mysterious and ancient wonders that draw blood when we tend them but are the living embodiment of romance and religion, poetry and legend. If your heart longs for roses, plant roses. Your doubts will remain for the first two or three years. Like most plants, roses focus first on growing roots. But there will come a day—probably in June—when you will step outside your home and straight into a fairy tale.

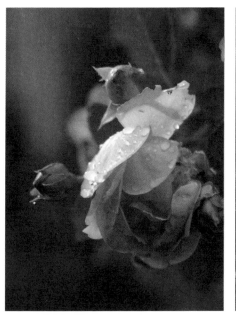

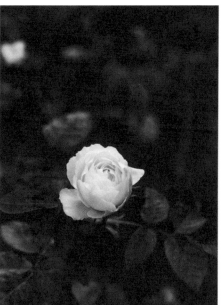

"This can't be real," you will say. But garden roses are proof that our best dreams really can come true.

Though not always. Two of my 'Fairy' roses never bloomed, and I never figured out why. Three years after planting them, I dug them out. The other roses flourished for years, but eventually my vegetable garden and its border of roses had to be asphalted over when we rebuilt our driveway. I will probably never grow 'William Baffin' again, but I am still searching for just the right spot for 'Bonica'. If I have any advice to offer regarding roses, it is this: *Dive in*. Give them a try. The only way to learn is with dirt under your nails. There is a great deal to study about roses, and they will respond to our knowledge of pruning and feeding. You'll find more technical advice in a later chapter. But here at the beginning I insist only on this: Flowers—and especially roses—are rooted in love. Growing flowers is a way of giving and receiving love. This means that successful gardeners

COMMON NAME: *rose* | **SCIENTIFIC NAME:** *Rosa*

MY FAVORITES: *'Bonica', 'Lady of Shalott', 'Queen of Sweden', and 'Olivia Rose Austin'*

REASONS TO LOVE ROSES: *The rose is the queen of the flower garden. Enough said.*

REMEMBER: *There is incredible variety within the rose family. Do your research and you'll find the right rose for you. This sort of research is my preferred activity for a cold winter night.*

are successful not because they know what they're doing but because their garden making is inspired by love. They *yearn* for beauty, and the price exacted by a thorn seems a very small price to pay.

Here is a simple recipe for romance: Identify your sunniest spot and your richest soil. For maximum bloom in the first year, order bare-root roses and plant them in earliest spring. If you are too eager to wait for next spring, plant a rose found growing in a container at a nursery. They can be added to the garden all summer long, but they may need an extra year or two to establish themselves. Don't bother amending your soil unless it is truly terrible. Instead, give your new rose bed a blanket of well-rotted manure. Choose your varieties with care. Read those catalog descriptions attentively, searching for roses that do well with the particular challenges of your climate, whether humidity or extreme winter cold. Remember that repeat blooms are nice, but roses that only bloom once in spring will flower more extravagantly than anything else in your garden. They are the roses of poetry, and every garden maker should grow at least one rose-scented poem.

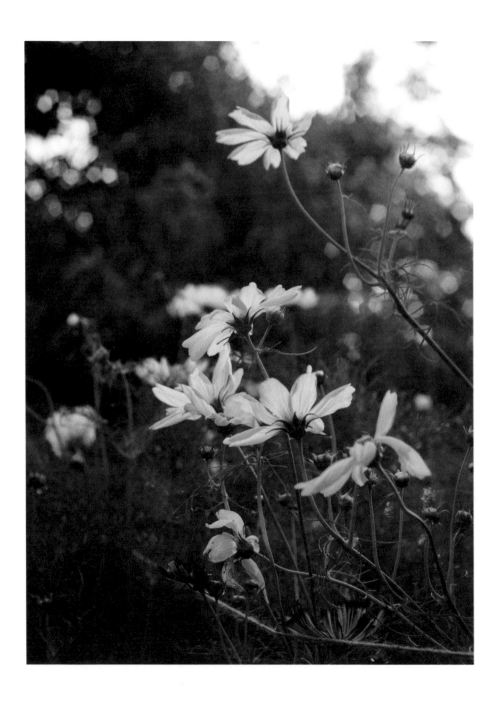

THE (ALMOST) INSTANT FLOWER GARDEN

Can't wait to dive in? Patience is a good thing for a garden, but if you want flowers now, and the temperatures are warm enough, you can have flowers in a few weeks. Here's an easy recipe:

INGREDIENTS
Seed packets of sun-loving annuals like cosmos, cornflowers, nasturtium, sunflowers, and zinnias

INSTRUCTIONS
1. Carefully cut out the grass from your chosen flower patch, leaving as much soil behind as possible. Use the sod to repair bare patches in your lawn or start a compost pile. If you'd like to grow flowers where only weeds are growing now, pull those weeds out by hand, roots and all.
2. Rough up the soil with a rake. You want dirt that is loose and smooth, not hard-packed or deeply furrowed.
3. Scatter your seeds.
4. Water well. Keep the ground damp until you see that the seeds have sprouted.
5. Keep your patch weeded and give supplemental water if weekly rainfall is less than an inch.
6. Cut as many flowers as you can. The more you cut, the more you'll grow (though non-branching varieties of sunflowers will only bloom once).

ALTERNATE INSTRUCTIONS
(This requires more time but less effort.)
1. Smother the area for your flower garden with a layer of brown cardboard. Wetting the cardboard with a garden hose can help keep it in place.
2. Layer compost or mulch on top of the cardboard, lots if you have it or just enough to keep the cardboard from blowing away.
3. Ignore your cardboard garden all winter.
4. In the spring, dig right through the softened cardboard to plant seeds or seedlings. Not only have the weeds and grass rotted away, but they have fed your soil in the process.

2

DREAM

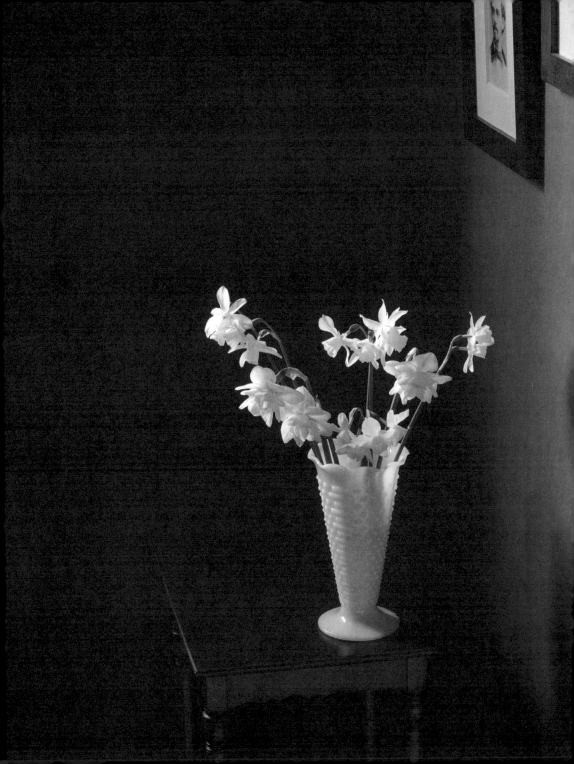

GARDEN DREAMS AND DESIGNS

GARDENERS NEED NOT HAVE "GREEN THUMBS," but they must be visionaries. I am sorry if that sounds daunting. I do not mean to put you off the whole business. The good news is this: If a visionary is someone who can imagine a better future, well, imagination is a muscle like any other, and it can be exercised. I recommend exercising it with graph paper, a freshly sharpened pencil, and a few seed and plant catalogs by your side. Proverbs 29:18 (KJV) tells us that "where there is no vision, the people perish." The same is more or less true of gardens. Without vision, a garden will never *become* at all, let alone perish. A garden, meaning a relationship of give and take between a person and her place, will—without vision—only ever be a hodgepodge of plants.

"As the years went by and age overtook her, there was something comical yet touching in her bedraggled appearance on this awesome occasion—the small, hunched-over figure, her studied absorption in the implausible notion that there would be yet another spring, oblivious to the ending of her own days, which she knew perfectly well was near at hand, sitting there with her detailed chart under those dark skies in the dying October, calmly plotting the resurrection."

E.B. WHITE, FROM THE FOREWORD TO *ONWARD AND UPWARD IN THE GARDEN*

How then to begin? With our eyes, of course. I once sat on a rocking chair on a wide front porch staring out at—emptiness. That might seem strange. Why were my eyes not drawn to the enormous Norway maple just to the right? Why were they not focused on the second enormous Norway maple just to the left? I think it was because when once we have given our imaginations freedom to roam, when we have quieted our thoughts and stilled our bodies, we begin to see what isn't. We begin to notice absence. The space between those trees was so very empty, a fact that those framing trunks only emphasized. As I rocked on my porch near my home's front door, my eyes were drawn again and again to that bare patch between the trees. It was open. It was sunny. It was blank. *Could I, maybe, grow flowers there?*

When we imagine, memories and long-buried desires are also set free. They flow into the empty space in front of our eyes and a picture develops; a possibility suggests itself. In this case, I began to see a picture of formality (four beds dissected by gravel paths), and I began to see romance (roses and lilies and every flower I had ever longed to grow). No doubt my imagination had been fertilized by the roses my father grew when I was a child and books like *The Secret Garden* that had once kept me company on long, hot southern afternoons. Life is noisy and our to-do lists always clamor, so it is no wonder we don't often heed, let alone hear, the soft whispers of memory and desire. When we still ourselves, we can hear them, and I think that our quietness is also a guard somehow against the practical worries and doubts that might hold back the rush of seeing. What I began to see was not yet reined in by concerns over time, labor, or funds. Those will be important later but not quite yet. Not at first. What *could be* is a fragile, skittish thing. Whatever we do, we must not scare it off with words like *impossible, why bother?* or *it can't be done.*

What is it we are trying so hard to see? What is it we are sketching into existence when we hover over our paper like God's Spirit over water? A garden is so much more than a shopping cartload of plants from the local nursery. It is a harmony. It is intentional. It is a living work of art. That "living" part is important because while a garden is always a planned space, it grows on the very edge of planned and unplanned. The unplanned weed? We pull it. The unplanned color combination? We give thanks for it.

The unexpected may become the final flourish, but our plan cannot begin there. It is best to begin with what we know. We must plan for light and for height, for shape and for color, for succession and for season. Is this a shady garden or a sunny one? Do we want cool colors or hot and bright? Will we have a pleasing mixture of shapes—some spiky, some round? Some spreading up? Some spreading out? Will this garden have color of interest all year round or only during one particular season? These are the questions we ask as we plan.

The gardener must see what *was*, what *is*, and what will *be*. And every garden—whether it lives on graph paper or has already begun to spread its roots—is a promise of something more yet to come. The empty place that so captured my attention from the front porch wasn't so empty after all. There were two enormous tree stumps visible just beneath the grass and weeds. Apparently, a whole line of Norway maples had once guarded the western edge of the house. We hired a man with a deep cutting machine to grind them up before we had a space truly empty enough for a garden. The emptier the space, the more easily I could see the paths, the corner fences—painted white or black? I wasn't yet sure. The central circular bed—filled with airy cosmos? Something perennial? Each question is a breadcrumb leading us toward what will be. And what will be is rooted deeply in our dreams.

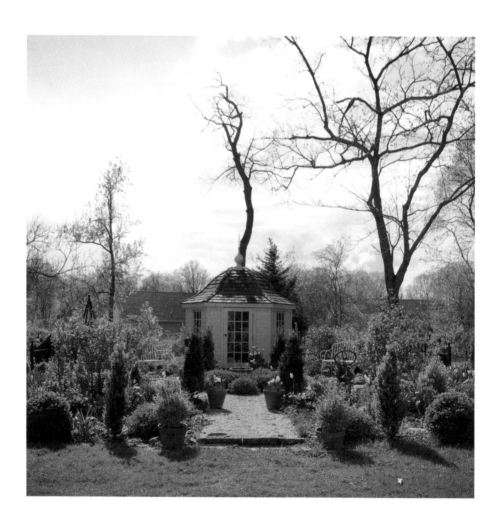

GARDEN STYLES

Gardens grow . . .

1. In Peter Rabbit rows with scarecrows standing guard.
2. In raised beds edged with untreated, rot-resistant wood like cedar and cypress.
3. In terra-cotta pots like the back porch at Grandmother's house or the elegant terrace at that Italian villa we visited one magic summer, long ago.
4. In front flower beds that defy the homeowners' association with their weedy exuberance.
5. In formal symmetry.
6. In jelly-bean curves.
7. In concert with weeds.
8. In mulched defiance of weeds.
9. Season after season after season.
10. Until they return to the earth like the gardener who tended them, resting and waiting for that resurrection day.

LET THERE BE LIGHT

WHEN GOD SAID "LET THERE BE LIGHT," THERE was light, and God saw that "the light was good." God, the first gardener, would no doubt agree that the goodness of light is various and changeable, a goodness that shifts and swings and moves. Light is no settled, static thing, a fact proven—if we are willing to pause in one place—by our own shifting shadow.

NORTH

My house is old and was planned like a perfect compass. The front porch faces north, and the light that comes in the front parlor windows is cool and slightly shady even when it shines. That cool northern light favors plants with "light shade" or "partial sun" on their labels, plants like hostas, ferns, and astilbes. But moving a little farther out from the house's shadow, even a sun-loving grass like prairie dropseed grows happily in northern light.

EAST

The eastern side of my home greets the sun in morning and the moon at night. The east-facing window in our stairwell is not so much a window as a frame waiting for a full moon. Eastern light is also cool, and with the house shading out the hot setting sun, I grow here those plants with sun-loving flowers and shade-loving leaves liable to burn: Hydrangeas and Japanese anemone appreciate morning sun and shady afternoons.

SOUTH

The back of my house, with its three tall kitchen windows, faces south. This sun is hot and golden, and I save it for roses and vegetables, ornamental grasses and—of course—sunflowers.

WEST

End of day brings the western light. It is hot but fading and can leave wilting plants in its wake. This light is like a fire burning down, destroying even as it disappears. Roses, phlox, and elderflower shrubs reach for it, but rather than being consumed, they are energized.

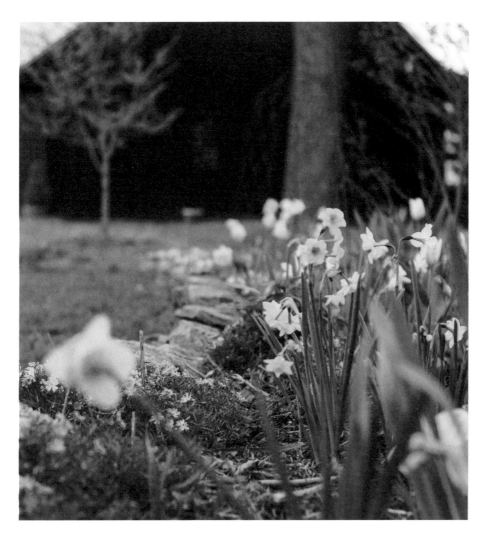

CATALOG OF DREAMS

I WAS A CHILD OF THE KING JAMES BIBLE AND the Sears catalog, big as a Bible. In my parents' home, the Bible was sometimes New King James or NIV. At my grandmother's farmhouse, the catalog was often JCPenney rather than Sears. I loved them all. I loved the sonorous poetry of those Bibles—to this day I can't recite Psalm 23 without every "thou" and "thy"—and the toy store of my dreams is still the back few pages of a catalog so heavy I'd need to lie again on my stomach in order to read it, cushioned in the shag carpeting my mother shampooed with the rental machine from the grocery store. My own children rarely hear the Bible in its "authorized" voice. Toy stores are a mobile app and a package on your porch two days later. And catalogs? To my children, those are just the magazines with flowers their mother reads all winter long. Those are the junk mail they dare not toss in the trash. If it has a flower on the cover, better put it on Mom's desk, they remind their dad.

———————+———————

"As I write, snow is falling outside my Maine window, and indoors all around me half a hundred garden catalogues are in bloom. I am an addict of this form of literature. . . . I read for news, for driblets of knowledge, for aesthetic pleasure, and at the same time I am planning the future, and so I read in a dream."

KATHERINE WHITE, *ONWARD AND UPWARD IN THE GARDEN*

Once upon a time, not that long ago, every seed order was penciled on a paper form, licked into an envelope, and dropped in the postal box with a wish and a prayer that the leeks would come in time for winter sowing. Now I, like every gardener, I suppose, place my order online. It seems the catalog would be superfluous. But, oh friend, it is anything but. Just as the e-reader did little to dampen our enthusiasm for wandering the dusty aisles of a secondhand bookstore, the seed seller's website saved us a stamp but did not slake our thirst for printed ink and paper promises. Pink-blooming marigolds? Extra-ruffled peonies? A rose that will bloom all summer long without a pause? I may believe less than half of the seed and plant seller's claims, but, oh, how I love to read them.

I could recommend catalogs to you for learning. And I do. Reading a seed or plant catalog is one of the easiest ways to meet a wide variety of garden-worthy plants. Some seed catalogs even have a uniquely educational mission. For instance, the catalog from Seed Savers Exchange will teach you how to save your own seeds and give you a way to trade them with others. I could recommend catalogs as accessible reference guides for garden planning. Though a book might tell you how tall shrub roses typically grow, a catalog will tell you just how tall your 'Bonica' is likely to be at maturity. But a website, of course, can also fulfill those roles. Ultimately, I don't recommend the regular reading of garden catalogs because they will help you become a better gardener (though they will), and I don't recommend reading them because they are as helpful as your graph paper and freshly sharpened pencil (though they are). I recommend to you the reading of catalogs because the reading of catalogs is one of the great pleasures of a gardening life.

Lately, the first seed and plant catalogs have begun showing up in my mailbox before Christmas Day. This is a recent development and a travesty.

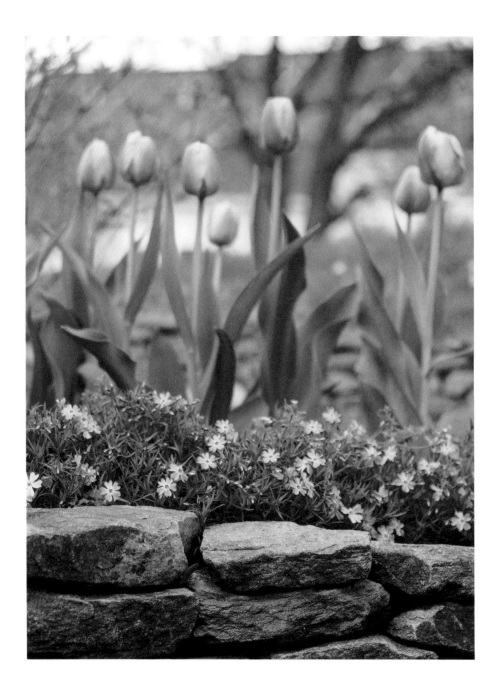

December is for Advent observance, tree trimming, and gift buying and making. January is for the garden, and I resent having my seasonal attention divided in this way. But I have learned to set aside those early-bird catalogs—though not in a pile on the kitchen table where they might be gathered up for the recycling bin with all the other junk mail. Instead, I clear a basket near my reading chair, the one tucked between the window and the fireplace, and I begin to gather the catalogs there. My anticipation grows as the stack grows. On New Year's Day, you will find me in that chair with a mug of chai in my hand and a catalog of dreams in my lap. I no longer care that cardboard boxes still teeter precariously in the corner or that bits of wrapping paper and ribbon curls are floating around the edges of the room. My head is in spring.

I once flipped the pages of the Sears catalog in order to pay homage to a piano-playing Barbie doll. Now I pay homage to the garden of my dreams, where every plant is in full flower and the sun is always shining. In some ways, the perfect plants of the catalog pages are as out of reach for me as that Barbie once was. A catalog image captures one moment in the life of a plant. We who grow them know that a garden is never made of a moment here or a moment there, and yet it is the moments that leave the deepest impression. Every gardener has her catalog of memories, and the Japanese beetles who devour rosebuds or the powdery mildew defacing the lower leaves of the phlox are present yet somehow diminished when we look back. It is the heady scent of the roses before the beetles arrive and the way the sun made the 'Daydream' cosmos glow that stay. And it is those images— those memories—combined with the catalog promises that restore my gardener's heart each winter. When spring comes, I am ready. Stuffed full of hopes and dreams and optimism, I am prepared to work again.

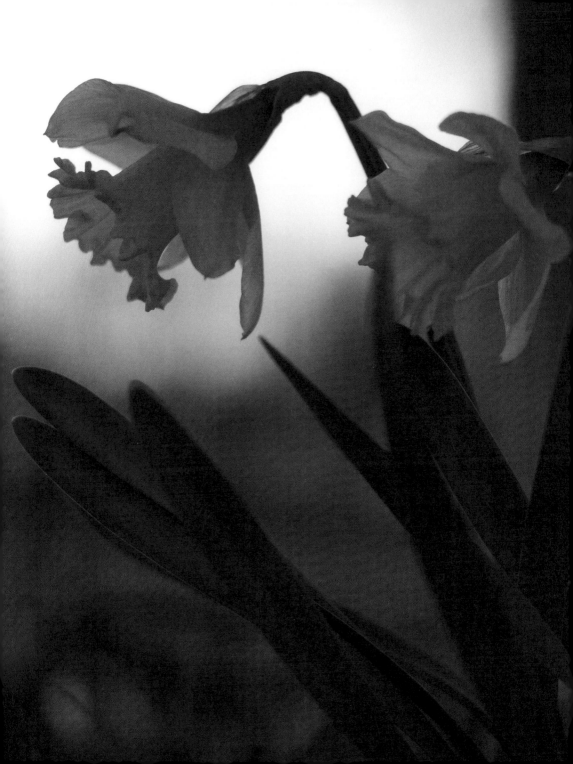

DAFFODIL SONGS

WE ARE INTRODUCED TO SOME FLOWERS ONLY in gardens. No one sings songs or writes poems about the enormous globe flowers of the allium, but every person who sees them growing in the flower garden at Maplehurst says, "Oh! What is it?" We are introduced to other flowers only in supermarket bouquets. I have never in my life seen ranunculus emerging from dark soil, but even peeking out of a plastic sleeve they are enticing. Some flowers, though, we first meet in art and song and story. For years, I encountered daffodils only in a tattered paperback copy of *The Secret Garden*. The pages were soft and beginning to yellow. The cover was mint green, the color of new life peeking out of winter snow—though I had no experience of such things in those days.

"Might I have a bit of earth?" Mary Lennox asks in that book. I read it through twice before slipping it back on the shelf above my twin bed and going in search of my father. He was a gardener. I would ask him for my own bit of earth. Searching for him in our Texas backyard, I felt the sting of mosquitos. The humidity was a wet towel over my head. *Never mind*, I said to myself, and I returned, for a third time, to Mary's paper garden and the black-and-white delights of a literary English spring.

Chief among those delights seemed to be the daffodils. Or "daffydowndillies," as the Yorkshire lad calls them before he asks Mary, "Has tha' never

———————+———————

"However many years she lived, Mary always felt that she should never forget that first morning when her garden began to grow."

FRANCES HODGSON BURNETT, *THE SECRET GARDEN*

seen them?" In the classic English children's literature I loved, these flow-
ers defined spring. Lifting their golden trumpets, they sang spring. Spring
in Texas gave no daffodils. It was defined by bluebonnets, bright blue living
streams bubbling up and flowing through pastures and alongside high-
ways. My books knew nothing of a Texas spring, and when I was young,
books were more real to me than anything I could see with my own eyes.
Books told me about the places in the world that mattered. Didn't they?

I planted daffodil bulbs my very first autumn at Maplehurst. I planted
them because I thought I loved them, which means I planted them because I
thought I knew them. But I did not. I knew an idea of them. I knew Dickon's
daffydowndillies and I knew the pretty yellow touches on the edge of a Tasha
Tudor illustration and, after earning an A minus in Romantic British Liter-
ature 201, I knew William Wordsworth wandering like a lonely cloud only
to be cheered by a host of golden flowers. But I still did not know daffodils.

Daffodils, much like roses, are powerful symbols. Their proper name,
Narcissus, sits at the center of a web of meaning, recalling Greek mythol-
ogy, psychiatric disorder, and more. The name, the image, the stories can
entice us and fuel our dreams. They have certainly fueled mine. But the
flowers are flowers, first and foremost, and we know them as flowers or
we don't really know them at all. If I say "daffodil," gardeners from Texas
to England will nod their heads, but if I share a photo of my 'Gay Tabor'
narcissus, almost everyone will ask, "What is that marvelous flower?"

We know a flower only when we grow a flower. We know a flower deeply
only when we grow a selection of that species. True knowing might take a
lifetime. And if our lives are really as ephemeral and fleeting as the life of
a flower, then I see every reason to spend my life growing (and knowing)
trumpet daffodil, double daffodil, cyclamineus daffodil, jonquilla daffodil,
tazetta daffodil, poeticus daffodil, collar daffodil, and miniature daffodil.

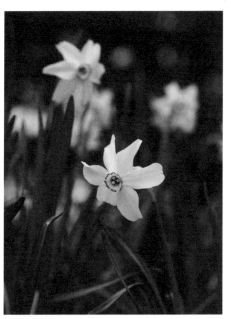
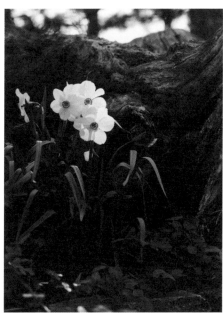

And—marvel upon marvel!—those are only the types. Each type or category of daffodil is filled by almost countless unique varieties, from recently created hybrids to heirloom flowers that have filled our gardens and our stories for generations. My favorite poeticus is 'Pheasant's Eye'; my favorite scented double is 'Bridal Crown'. Perhaps I will discover a new favorite

next spring. Where has my Brent and Becky's bulb catalog gone again? I will read it tonight before bed. I will read it like a collection of poems.

If the knowing takes a lifetime (and what better way to spend a lifetime?), the growing takes a lifetime as well. I think most of us know this, but I also think most of us feel discouraged by the thought: *I'm only a beginner. Why did I wait so long to garden? How will I ever learn what I need to know?* Whether by mosquitos or lack of knowledge, we are so easily discouraged. We are so easily contented with paper ideas and paper symbols. As it turns out, not even south Texas growers need be discouraged. My favorite online purveyor of bulbs, Brent and Becky's, will mail you a selection of "pre-cooled bulbs for southern and temperate landscapes." So go ahead. Plant a little symbol, a little England, a little poem in a pot. For we are never pure beginners. By the time we approach a bulb catalog, and long before we bury that bulb in dirt, the roots of our future gardens stretch far out behind us, sunk deep in a lifetime of stories and dreams.

COMMON NAME: *daffodil, jonquil*

SCIENTIFIC NAME: *Narcissus*

MY FAVORITES: *'Ice Follies', 'Bridal Crown', 'Gay Tabor', 'Manly', 'Thalia', 'Erlicheer', and 'Pheasant's Eye' (or poeticus var. recurvus)*

REASONS TO LOVE DAFFODILS: *Deer, squirrels, and other garden pests will not touch them. Some varieties have an astonishing spicy scent. They return year after year.*

REMEMBER: *Order your bulbs in spring while they are on your mind. They will be shipped to you at just the right time for fall planting.*

3

SOW

SEEDS: READY, SET, GROW

MOST OF US HAVE A MEMORY LIKE THIS: A ROOM full of squirming child bodies, a slick desktop with a groove for our yellow pencil, and a paper cup of dirt waiting for its seed and its black marker signature. We push in a fat seed with our fingertip. We write "bean" with our Crayola marker. We add our name. That memory sometimes returns to me in the dentist's chair when I am handed that little paper cup. It returns to me when my own child brings me a paper cup marked "sunflower" for Mother's Day.

The lessons of bean or sunflower and paper cup usually don't stick, do they? Years and years passed between the day I gave my mother responsibility for my paper cup garden and the day I planted a seed again. I gardened for ten years in city apartments and urban community gardens without ever sowing seeds. Even my lettuces were purchased as seedlings from a folding table at the neighborhood plant sale.

There is nothing wrong with that. I was a real gardener doing real gardening. And yet my reliance on plants someone else had grown from seed

———————|———————

"Sooner or later, every person feels this desire to plant something. It is the return to Eden, the return to ourselves after the long estrangement of our artificial lives."

LIBERTY HYDE BAILEY

set up a mental hurdle I became reluctant to jump. In my mind, some aspects of gardening were "difficult" or "too much trouble," and I would leave them to the hands of others. When I moved to Florida and felt overwhelmed by my first ever backyard, my sister gave me one bit of advice: "Buy a packet of zinnia seeds. Toss them in your beds. See what happens."

What happened felt like a miracle, yet I had no real reason to be surprised. I tossed out zinnia seeds, and zinnia flowers grew. That's how it works. Yet I had convinced myself it was harder than that. I had convinced myself that growing flowers from seed was Advanced Level Gardening—amateurs need not apply. I had forgotten the sunflower that once grew in my family's Texas backyard. To a child it was as tall as a skyscraper. Rising against our back fence, it competed with our neighbor's fancy bird condo for height. But even more surprising than the fact of the sunflower itself was my father's explanation. He told me he hadn't planted any sunflowers that year. "A bird must have dropped the seed," he said.

Friends, if birds can do it, if kindergarten children can do it, we can do it. But *why* should we do it? We do it, first of all, for freedom. Plant a packet of zinnia seeds, and you will realize you no longer need someone else to do this for you. Plant a packet of zinnia seeds, one hundred seeds in a packet you bought for $2.95 at the grocery store, and you will realize just how many flowers it is now possible for you to grow. That six-pack of zinnias on clearance at the garden store no longer looks like such a bargain.

We do it for the flowers. Ready-grown zinnias at the garden center come in red and yellow. Also orange, probably. But those are simply the colors some commercial-scale grower thought most likely to sell. Zinnias have been bred in so many beautiful shades. There are huge zinnias in rainbow colors like the 'Benary's Giant' types. There are tiny little zinnias like 'Lil-liput', perfect for pots and the edge of a raised bed. There are zinnias in

subtle antique shades of lime and rose, like 'Queen Lime' and 'Queen Red Lime'. And the same is true for so many flowers. Want an heirloom sweet pea full of scent or the latest thing in cosmos? You will only find those flowers in a seed packet.

The paper cups we used in kindergarten are an option. There is no need to purchase fancy lights and shelves and growing medium from a catalog. A very sunny windowsill and a recycled yogurt cup with drainage holes cut into its bottom are really all you need to begin. Some flowers do just fine—or perhaps better—if we plant their seeds directly in our gardens. Zinnias and cosmos and sunflowers are this way. But I still prefer to start a few early. I make a head start on the growing season, and I am able to place a good-sized plant right into my garden without worrying it will be overshadowed by its neighbors.

Recently, I was showing my husband around the garden, and I found myself saying again and again, "I started this from seed. I started this over here from seed." I wasn't bragging so much as marveling. This tall, purple-flowering hyssop releasing its licorice smell when I rub its leaves between my fingers—I planted a seed and now *this*? The snapdragons opening pale pink flowers from the bottom up on their reaching spikes—they grew from a miniscule seed? I've been sowing seeds for years now. Seeds in the garden and seeds in yogurt pots. Seeds in compostable pots and seeds in those plastic clamshell produce containers. Sowing all those seeds myself has drawn me deeper into the garden. Yes, I've saved some money. Yes, I've grown some rare varieties. But the reason I place a large order for seeds every winter is because these seeds grow more than flowers. They grow a connection between me and my garden that is deeper, richer, and more complete. Seeds have rooted me in this place.

SUPPLIES FOR GROWING FLOWERS FROM SEED

Theoretically you could hold fine-textured soil in your cupped hands and watch as a seed grows in it. But that would require more stillness than most of us can give. Here are a few better options, though I do recommend taking the time not only to water but to observe quietly. Unlike those pots of water we want to boil, the seeds we want to germinate do seem to appreciate an audience. Fill any of the following containers with a commercial seed-starting mixture. Unlike potting soil for containers, these mixes have a fine texture and are completely sterile in order to give seeds the best start.

— Reuse plastic yogurt cups (but don't forget to cut a few drainage holes in the bottom).

— Use clamshell produce containers that were once home to strawberries or salad greens.

— Form toilet paper rolls into seedling pots.

— Fold newspaper into cups.

— Plant biodegradable pots straight into the garden, and the roots will grow right through them.

— Wash small plastic pots from a garden center well and reuse for your own seeds.

— My favorite? Invest in a long-lasting soil blocker tool and make neat little blocks of soil. Soil blocks reduce the shock of transplanting because the roots are "air pruned" when they reach the edge of the soil.

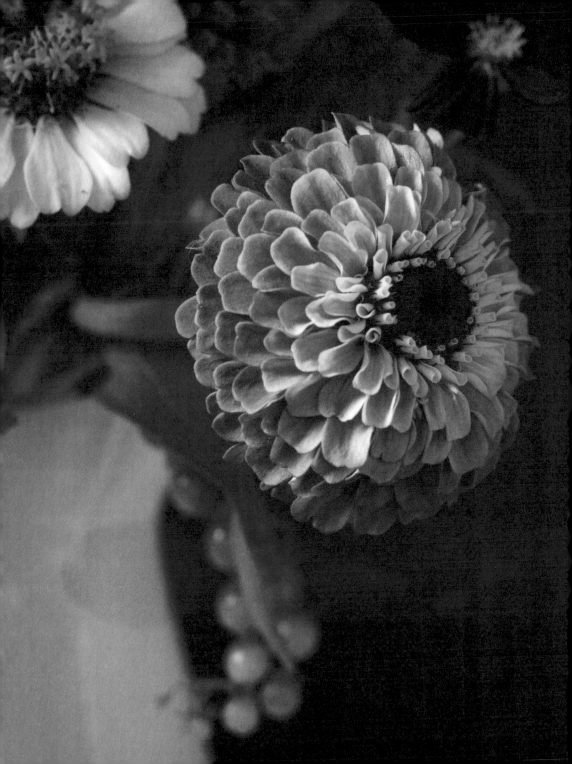

PLANT A ZINNIA, PLANT RETURN

ONCE UPON A TIME, ZINNIAS DIDN'T MEAN anything. Not to me, at least. I understood that the word identified a flower. It may have brought a vaguely daisylike picture to mind, but the details were as fuzzy as the bumblebee I could not see collecting pollen from center florets that looked—I did not then know—exactly like a circle of yellow starfish.

I originally intended to tell you I did not know about zinnias because zinnias did not appear in the books I read as a child. Weeds like buttercup did. Roses certainly did. Even Iris and Narcissus I knew from my much-loved copy of *D'Aulaires' Book of Greek Myths*. But then I did a bit of research and found that one of my favorite literary heroines *did* have something to say about zinnias:

> "[Poppies] have only a day to live," admitted Anne, "but how imperially, how gorgeous they live it! Isn't that better than being a stiff horrible zinnia that lasts practically for ever? We have no zinnias at Ingleside. They're the only flowers we are not friends with. Susan won't even speak to them."[1]

———————————+———————————

"In my beginning is my end."

T.S. ELIOT, *FOUR QUARTETS*

———————

[1] L.M. Montgomery, *Anne of Ingleside* (Toronto, Ontario: Seal Books, 1983), 82.

L.M. Montgomery's Anne-with-an-e may have lived her fictional life nearly a century before me, but she became a guide for my own aesthetic tastes. I learned of (and learned to love) the paintings of Titian through her. The word *auburn* held almost unimaginable appeal (though my own hair was neither auburn like Anne's nor raven like Diana's but a thoroughly unimaginative brown). Anne loved Tennyson, so one of the first paperbacks I bought with my own money was a cheap student copy of *Idylls of the King*. But while Anne's tastes in art and poetry intrigued me, her opinions about flowers went zipping right past my head like that unseen bumblebee carrying its pollen home.

Strange, then, that my flower gardening life would begin in earnest with zinnias. My sister's advice for my Florida backyard changed more than the foundation plantings around my suburban house. It changed my *life*. I struggled to feel rooted in that Florida home the entire time we lived there. The zinnias were my stamp on the place, my own signature written in red and orange ink amongst the green shrubs whose names I did not know and the spiky cactus and rough palms—whose names I did not care to know—that I only hoped would not injure my children as they played. My own gardener father was nervous about the pampas grass that grew in the corner of our yard. He warned me about its dangers. Perhaps the leaves were a choking hazard? Or could somehow hurt a child's throat? I can no longer recall what he told me, but I do know this: *No one's gardening father ever issued warnings about cheerful, happy zinnia flowers.*

Stiff and horrible, perhaps, but long-lasting and easy to grow, most certainly. It is true that zinnias do not dance in the wind, but when you first begin to grow your own flowers, dancing is the last thing on your mind. The path from seed to flower is all I cared about. If I scattered these seeds on the soil, would they, *could they*, grow flowers? It all seems so impossible

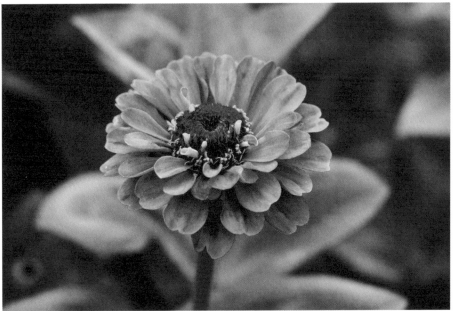

COMMON NAME: *zinnia* | **SCIENTIFIC NAME:** *Zinnia*

MY FAVORITES: *'Benary's Giant', 'Lilliput', and 'Queen Red Lime'*

REASONS TO LOVE ZINNIAS: *Easy to grow from seed. They thrive in the heat of summer.*

REMEMBER: *Most individual zinnias will not bloom without decline from May to November. Eventually, these annuals will tire themselves out, but zinnias are a great candidate for succession planting. I grow some from seed in spring and extend my harvest by sowing more zinnia seeds in early summer. My summer-sown zinnias bloom until the first hard frost.*

at first. Surely a hundred things could go wrong. But zinnias come to our rescue. Unlike the purple poppies that did not germinate at all the first time I tried sowing them, zinnias catapult us past our fears and doubts and make us gardeners. Just like that.

Perhaps Anne could sneer at zinnias—so stiff, so horrible—because she'd grown up with abundant Prince Edward Island flowers. Who needs zinnias when poppies thrive in cool Canadian summers? But I live where summers are hot and humid and too many flowers do not thrive in August. Stiff and strong is exactly what my climate calls for. And though I now grow my own poppies, and though I now love to watch them dance in the wind, ten years since that Florida flower patch, I grow more zinnias than I ever have before. I may be a fully grown gardener now, but I have not and will not "put away childish things," as the King James puts it. Zinnias are for children (those simple shapes and bright colors!) and they are for beginners (so easy and so vigorous!), but they are more than ever the flowers for me.

Today, I grow zinnias in pots. 'Oklahoma Ivory' is a lovely, pale flower that shines on the patio after dark. I grow zinnias around my vegetables. 'Lilliput' is happiness personified but not so big that it will block the sun from the green beans. I grow zinnias in neat rows in an area of simple raised beds that I call my "cutting garden." Here I plant the subtle, antiqued shades that defy Anne's easy dismissal. I'm quite sure I have a zinnia this summer that could only be called auburn. I think it would look just right held in the hands of the tragic Lady of Shalott.

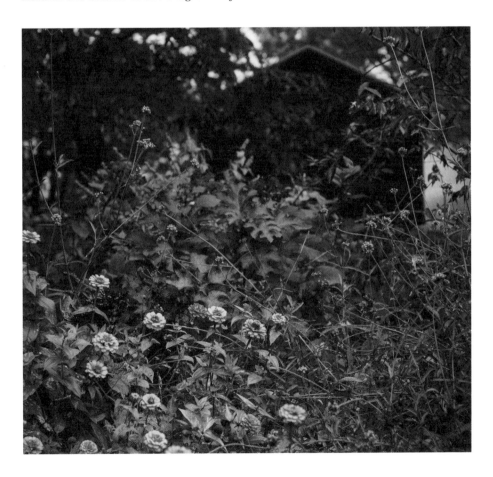

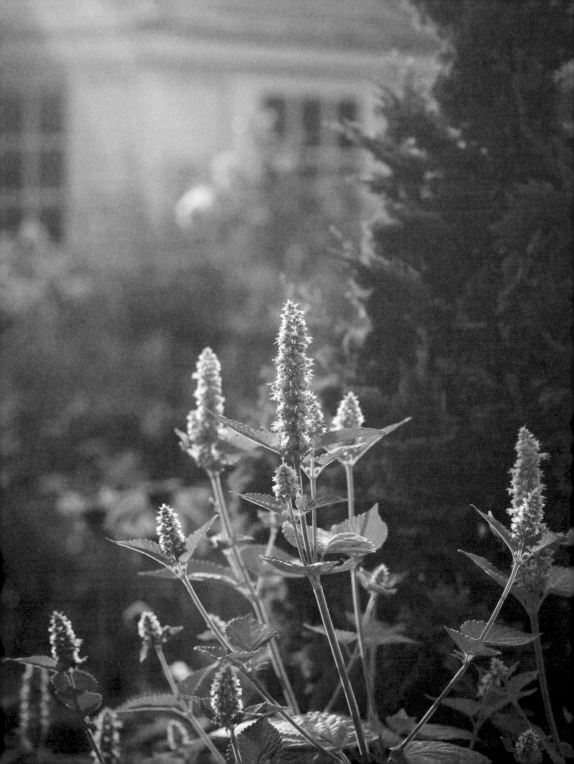

WONDER FLOWERS
AND SUPER PLANTS

GARDEN EVEN FOR A SHORT WHILE, AND YOU WILL join the ranks of those searching for the one magic plant that will solve all of our most pressing garden problems. Often we're looking for a groundcover plant. Ground *wants* desperately to keep itself covered, but weeds are the only plants that seem especially eager for the job. This has not stopped me from devouring every garden book with "groundcover" in the title. Or, we might be always on the lookout for something that will grow in our problem area—flowers that bloom in dry shade, for instance, or plants that thrive in boggy, wet soil. Most of us, no matter how different our gardens, are searching for the plant that will tie everything else in our garden together, stay healthy, require little care, flower for months, and—in winter—look good with a dusting of snow. Where is the section in the garden catalog for wonder flowers? Where is the aisle at the garden center for super plants?

I am often asked for garden advice, and every time I wish I could simply name one super plant to solve every problem. But I have learned that while

———————————————

"Provided you don't actually plant something still in its plastic pot . . .
you have a very sporting chance that it will wax strong, healthy and
floriferous. If you don't believe me, why are there so many gardeners?
Surely if it were really difficult, like calligraphy, say, you wouldn't
meet very many people who did it, would you?"

URSULA BUCHAN, *BACK TO THE GARDEN*

wonder flowers and super plants *do* exist, they are shape-shifters. They are different for every gardener and every place. My super flower might be your invasive nightmare. My wonder plant might clash with your careful color scheme. My clay soil might adore the very plant your sandy spot abhors. While the notion of one plant to fill all our garden needs is enticing, the reality is more interesting and more complex. After all, the challenges are what make a quest so meaningful and transformative. I am always on that journey to find the plant that will "save" my garden. If you've been gardening for any length of time, then no doubt you are on that journey too. Our paths are not identical. They will not lead us to the same destination. But like the plot of every fairy tale, the basic structure of our journeys is much alike. And like every fairy-tale quest, we gather treasures along the way, like bread crumbs or white pebbles or jewels from a secret hoard. Here are some of the treasures I've collected on my way:

ANISE HYSSOP (*AGASTACHE FOENICULUM*)

An easy-to-start-from-seed perennial is anise hyssop. It's a tall plant that quickly fills space in the garden, and though each individual plant may not last for many years, anise hyssop seeds itself around, which means you'll always have it popping up somewhere. Depending on your own garden style, this is either a good thing or a bad thing. At Maplehurst, seeing this sweetly scented plant with its purple flower spikes (usually with a bee or butterfly in close proximity) is always a good thing. Did I mention the leaves make a delicious iced tea?

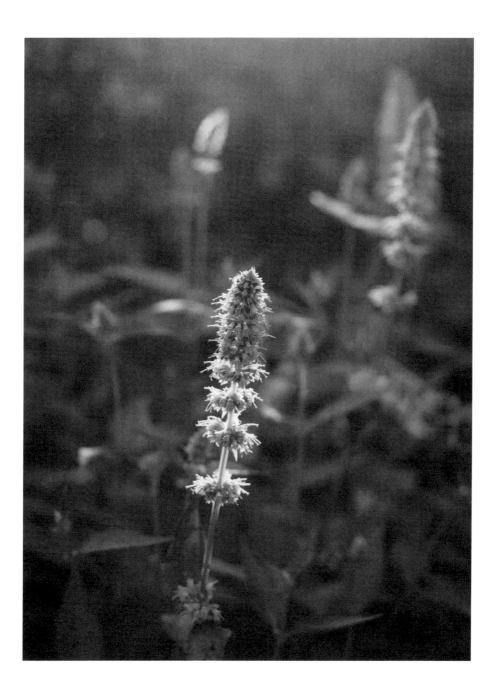

VERBASCUM 'SOUTHERN CHARM'

Verbascum, commonly called mullein, is a fairy-tale plant, and this partic-
ular variety is a Prince Charming in my flower garden and my raised bed
cutting garden. Tall, romantic flower spikes lift their heads far above the
plant's base in antique shades of rose and ivory. 'Southern Charm' looks
good in the garden and glorious in a vase. Although it isn't a very long-lived
perennial, it does return (especially if I remember to cut back the dead
flower spikes and cover it with mulch). But best of all? It is very easy to
grow from seed. I like to start at least a few new plants each spring to keep
a steady supply flourishing in my garden.

CATMINT (*NEPETA*)

If you long to grow lavender (as I do) but garden on heavy clay soil (as I do), then you must meet my friend *Nepeta*. I especially appreciate the variety called 'Walker's Low'. Despite its name, it is a tall catmint with gorgeous wands of purple flowers. My garden books tell me I should cut back the flowers after bloom in order to encourage fresh flowering, but I love the faded colors of the spent flowers too, so only rarely do I bother to cut my nepeta back. In late May and early June it is a vivid, stunning purple. Then all summer long it gives the garden a lavender and silver sheen.

Catmint is easy to propagate and spread around the garden through division. It needs little special care other than cutting back last year's dried stems in late winter. I actually love this chore because it takes the garden straight from tired-of-winter to ready-for-spring.

TEND

THE ETERNAL WEED

WHAT IS A WEED? THAT MIGHT SOUND LIKE A PHILOSOPHICAL question. It certainly does when Ralph Waldo Emerson answers it by telling us a weed is "a plant whose virtues have not yet been discovered." Yet for the gardener, this question is utterly practical. Is this small green sprout just beginning to show itself in my flower border a weed? By which we mean, *Do I yank this out or leave it be?*

Depending on the place and the person, the answer will not always be the same. While some growing things do unequivocally bear the title of *weed*, some, like dandelions, are a test of character. I don't have quite so high an opinion of the dandelion-free lawn and its chemical-wielding caretaker as I do of the gardener who picks her yellow flowers to flavor dandelion cupcakes. And if she makes her own wild violet syrup with which to flavor the frosting? Surely there is some public commendation we can award her—though I suppose her children will at least rise up and call her blessed.

"The man who worries morning and night about the dandelions in the lawn will find great relief in loving the dandelions. . . . Little children love the dandelions: why may not we? Love the things nearest at hand; and love intensely."

LIBERTY HYDE BAILEY

Perhaps these "less than clearly weeds" should be called *philosophical* weeds. These are the plants, like wild violets, that regularly challenge the gardener's need for control. For the first year after making my flower garden, I pulled the wild violets that crept in from the lawn. But as the violets kept on creeping, I gave up. Or perhaps I could say I changed my mind. Instead of calling them weeds, I began calling them groundcover. Now I think of them as exactly the spring-blooming, native groundcover my garden needed.

Pokeweed is another philosophical conundrum. It has *weed* right there in the name, and yet I once saw it featured as a precious garden specimen on the British television show *Gardeners' World*. While British gardeners cosset their North American pokeweed with its deep purple berries, I pull mine out wherever I find it. Though now when I miss a spot and discover eight-foot plants dangling berries on the edges of my garden, I think of those UK gardeners and decide not to be too annoyed. The pokeweed berries are good food for birds. Purslane is another so-called weed that pops up in my vegetable garden, but I have generally welcomed it ever since spying a basket of purslane sold as a fancy salad addition on the table of a downtown Chicago farmers' market. It's hard to hate a plant some urban shopper would gladly pay five dollars for a handful.

Still, there are weeds that are anything but philosophical. These plants I have no trouble calling weeds. They are sneaky and malicious, like the bindweed twirling so daintily up the stalk of my lily in order to choke the life out of it. They are aggressive and bullying, like the crabgrass that plants itself in the midst of my dahlias. Some weeds are quiet but terrible, like the Japanese stiltgrass that grows far beneath my radar, shaded by the leaves of every other plant until the day I turn around and discover my beloved flower garden has disappeared beneath a haze of soft, green grass.

These—the bindweed, the crabgrass, the stiltgrass, and their ilk—are the eternal weeds. Though unique in their methods—deep taproot? winding stem? shade tolerance?—together they dissolve in my mind into a single, archetypal Weed with a capital *W*. They are my constant garden companions. They are my nemesis, and as such, they are the very things that give a form and a direction to my work. What would gardening be without them?

Certainly, without weeds there would be more admiration and less participation. We gardeners would have far less dirt under our fingernails, in every sense. Though I hate them, though I would wish them away if I could, they are also the source of a great portion of my satisfaction. Is there any accomplishment more gratifying than a bed newly cleared of weeds? In a disembodied world of digital, virtual work, there are too few tasks left with such clear and obvious metrics.

If I seem to be saying that weeds give us gardeners something to occupy our time, you would be right in replying that we gardeners must lead quite empty lives. What I am trying to say is that weeds pull us into our gardens. They get us down on our (creaking, aching) knees, where we might otherwise only go at planting time. Weeds are like Alice's "Drink Me" bottle. They say "Pull me" and thus pull us right in and down and make us small to see the inner workings of everything. While weeding, I see the way the stem of a cosmos has lain down on the soil and grown new roots in that place. While weeding, I take up my place within the garden, rather than continue towering above it. While weeding, the whole world shrinks and shrinks, becoming so much bigger than I ever knew it was.

THE CARE AND KEEPING OF GARDENS

Garden making is never finished because gardens are never finished. Just as our own living bodies need regular food and rest and care, so do gardens. Caretaking is not duty or drudgery. It is partaking. Here are some of the simple ways we add our own voice to the garden's song:

— Weeding: Think of this as editing a school paper or dusting the living room furniture. It is best done after a rain (when the weeds are easy to pull). Fingers work well, but long-handled shuffle hoes and short-handled Japanese weeding tools work even better.

— Mulching: Soil needs to stay covered. It will cover itself with weeds, or we can cover it with mulch, suppressing weeds and conserving moisture. An excellent mulch will even feed plants and improve the structure of the soil as it breaks down.

— Watering: This requires observation. Keep a rain gauge so you don't water unnecessarily. Stick your finger down into a container to feel for moisture. It's better to water less often but more thoroughly than to give a light sprinkle every day.

— Deadheading: Many plants (though not all) will give more flowers over longer periods of time if they are regularly and thoroughly deadheaded. A horrible term, it simply means to remove the dead or dying flower heads before they become seeds. Roses especially need deadheading. Annual flowers like cosmos and zinnias do too, but here duty and joy merge. If I cut a bouquet of zinnias for the kitchen table, am I enjoying the flowers or deadheading the plant? The happy answer is: *both*.

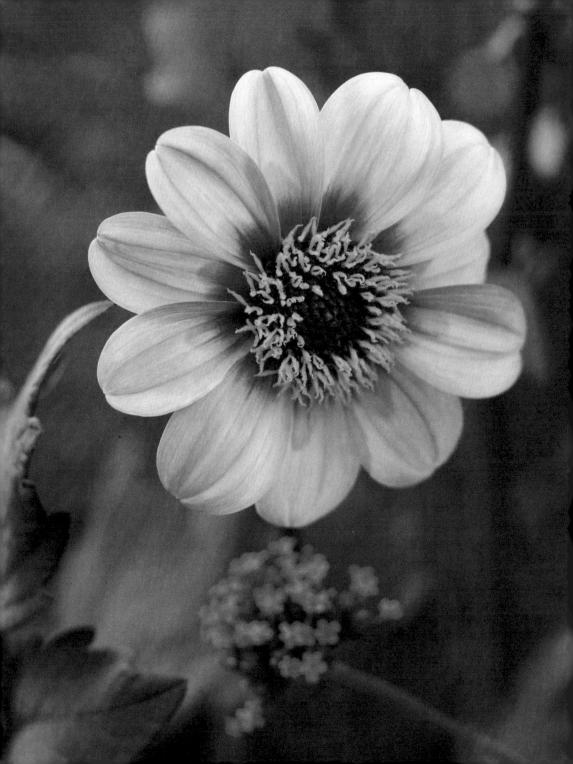

DAHLIA TROUBLE

"WHAT DO DAHLIAS LOOK LIKE?" MY FRIEND Lisa-Jo asked. I'd been complaining about my busy work schedule and had mentioned there'd been no time to dig up my dahlia tubers in November. Now I worried I would lose them all to rot over the winter.

"What do they look like?" I said. "I don't know how to answer that. They come in just about every color and shape. Some look like daisies. Some look like water lilies. Some are tiny pom-poms, and some are as big as dinner plates."

"That's no help," she said. I laughed.

I had never heard of dahlias, never set eyes on them as far as I knew, until at some point in my mid-twenties I read an article about growing dahlias in an issue of *Martha Stewart Living* magazine. In those pre-Pinterest days, I read that magazine for recipes and stories about repurposing oddball antiques into everyday objects of usefulness. I had begun growing vegetables with a few friends in a Chicago community garden plot, but I was only marginally interested in the magazine's garden tips. I remember reading the dahlia story with a growing sense of bewilderment. I read

"Let me pay the dahlia the high tribute, then, of saying I do not grow them, have no space for them, and harbor suspicions against them as not being quite up to the chief garden flowers, and yet when I see them well grown I head home with absurd resolves to chop everything down and grow great beds of dahlias."

HENRY MITCHELL, "THE DELIGHT OF DAHLIAS"

about planting tubers in the spring and digging them up again in the fall. I read about elaborate staking methods with canes and twine. I read that competitive growers (*there are dahlia competitions?*) plucked off buds in order to force the plant's energy into fewer flowers, turning saucer-sized blooms into platters. I remember closing the magazine and thinking to myself, *Well. At least I know now I will never grow dahlias.*

Bless your heart, I want to say to my younger self. *You have no idea what's coming.* What was coming was a twenty-foot-long dahlia border my husband made—complete with dry-stacked stone retaining walls—for my fortieth birthday. Even though that border has grown increasingly shady at one end (thank you, enormous apricot tree), it still holds dozens of dahlias. I also have a cut flower garden where I raise a half dozen more in raised beds. How did I move from bewilderment to obsession?

It started so quietly. An interior design blogger who typically wrote about the inside of her Victorian house published a post about her garden with an emphasis on "easy" flowers. To my surprise, she recommended dahlias. *Dahlias?* I wondered. Yes, dahlias. But where the magazine article had been overwhelming in its details and staggering in its possibilities for colors, forms, and chores, the blogger made a simple proposition: *If you're not sure you want to bother digging up your tubers for winter storage, then don't. Maybe they'll come back, maybe they won't, but you can always buy new tubers next year.* Then she linked to her favorite mail-order source, Swan Island Dahlias, explained her preference for the delicate "waterlily" types, and mentioned five of the dahlias she'd ordered for her garden that year. I clicked the link, decided I liked the purples and pinks she'd chosen, and clicked "buy." Then I googled "how to grow a dahlia."

Because my first exposure to dahlias had come through a magazine that emphasized perfection, I had assumed dahlias were too much work for me.

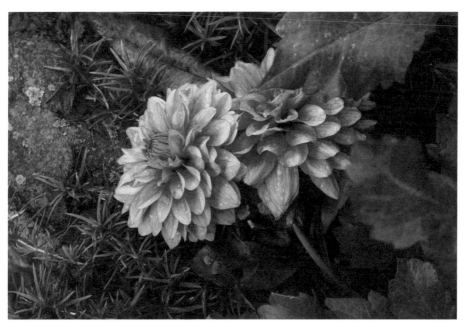

Somehow I had not understood that there are no dahlia police. There are no garden police at all, for that matter. If I didn't properly stake my dahlia and it flopped over in a storm? Not the end of the world. If the first freeze came in the fall and I didn't feel like digging my tubers up and storing them in the basement? Not the end of the world. But if the tubers I buried in May began throwing out water lily-shaped flowers in every shade of pink and purple in July? Well, then, welcome to a whole *new* world.

Welcome to a world of flowers that only grow more prolific and more beautiful the nearer we come to winter. Welcome to flowers that make a powerful statement in the flower border and in a vase on the table. Welcome to the world of dahlias. You won't want to leave—I promise. Today, I appreciate the challenge of trying to grow a large dahlia like 'Café au Lait'. It needs staking (I've tried a dozen methods and will probably try a dozen more before I die). Some years it grows well and some years it seems to sulk, but just when I swear I'll never grow it again, it gives one perfect and enormous flower shaded pale pink to cream to lemon, and I fall in love all

COMMON NAME: *dahlia* | **SCIENTIFIC NAME:** *Dahlia*

MY FAVORITES: *'Café au Lait', 'David Howard', 'Boogie Nites', and 'Fashion Monger'*

REASONS TO LOVE DAHLIAS: *Dahlias make beautiful cut flowers and garden flowers. They also flower best from late summer to fall when so much else has grown tired.*

REMEMBER: *There is enormous diversity in dahlia varieties. Do your research to find the ones that suit your garden style. There are dwarf dahlias great for containers, enormous "dinnerplate" dahlias that need strong stakes but make stunning bouquets, and medium-sized dahlias that bloom all summer without staking in a garden border.*

over again. Today, I also appreciate the easy dahlias like 'Sweet Tiamo', which gives flower after flower after flower in my favorite shade of pink, and the 'Happy Single' dahlia series. These dahlia plants are shorter, so they need no staking, and their dark purple, almost black leaves look amazing in a flower border. Growing dahlias is like growing a flower shop in your backyard.

It's sobering to think how near I came to missing out on them. How often do I encounter something new and decide it must be too much trouble? Or too risky? Or something only *other* people do? Why aren't life's good gifts easier to recognize at first sight? And what does a good gift look like, anyway? Maybe good gifts come disguised as water lilies and pom-poms and dinner plates. Maybe good gifts come disguised as too much trouble.

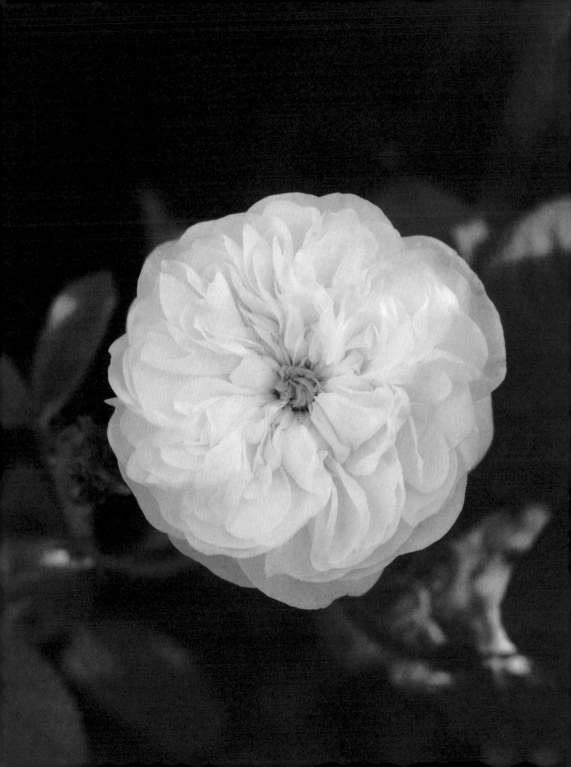

ROSES PART TWO
All Hail the Queen

IN THE WINTER, I THINK GREEN THOUGHTS, AND I dream of roses. I read books and catalogs, and I make lists. In spring, I plant new roses, wishing with every one that I had yet more roses to plant. In early summer, I remember that there is a manageable gardener-to-rose ratio, and I have foolishly surpassed it. My roses need tending, but I am one, and they are many. Yet I go on wanting more.

I think this love of roses may be akin to sickness. Addiction. Obsession. It does not seem quite proper. Certainly not healthy. Healthy would be a sober appreciation for coneflowers. They are stiff and strong and look good in their fresh summer petals and in their dried winter seedheads. They look good right close up, and they stand out from far away. They sing a happy summer song and mix well with others.

Roses, in contrast, are moody and demanding. Their music is violin, not guitar. A just-opened bloom of 'Blanc Double du Coubert' is the most perfect thing in the universe. Until it rains and the blossom melts into a blob of soggy petals like rumpled Kleenex on a bush. I adore it anyhow. It smells like the very definition of perfume. The rose evangelists will insist we must

"Annihilating all that's made
To a green thought in a green shade."

ANDREW MARVELL

only choose the right rose for the right place to ensure an easy, carefree addition to our gardens. They are lying. There is never anything easy about roses. The thorns at the very least see to that.

Roses give and they take. They will greedily eat up all the compost you give them. They will flower on and on but only if you deadhead them. They will make you ever-so-slightly dissatisfied with every other flower growing in your garden. The alliums are wonderful, the zinnias delightful, but why can't everything be a rose? It is true that some roses do not need much tending, but in return they will swallow the shed you planted them against. They will dangle their canes over the garden bench, making it impossible to sit down. Yes, you could cut her back or dig her out, but you would rather just give up any claim to the bench. The roses are in charge now.

What does it take to tend a rose? First comes the winter protection. Not all roses need it and certainly not all winter climates require it, but I have a few roses planted in an exposed corner of my yard. Winter's north wind can be deadly for some of my less hardy roses, so every November I mound quite a bit of mulch at their bases. I wrap my climbing 'Souvenir de la Malmaison' rose in burlap. In spring, there is pruning. The bright yellow of the forsythia is my signal to pull out my sharpest snips. I cut the large shrub roses back by a third. I cut out any diseased and damaged wood. I always make a slanting cut. I am careful to cut just above an outward-facing bud. That cut will encourage new growth away from the rose's interior. This task is both exciting (the roses are coming! the roses are coming!) and endless (*how* many roses have I planted in this garden?).

When the roses begin to flower, my constant deadheading begins. Prevent a rose flower from becoming a rose seed (or "hip"), and your rose will go on making flowers. Deadheading is a way of fooling a rose into producing more flowers, but every gardener knows that a rose is no fool.

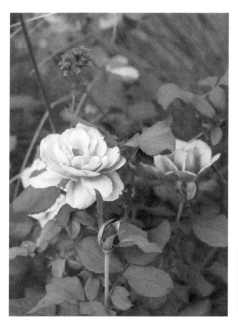
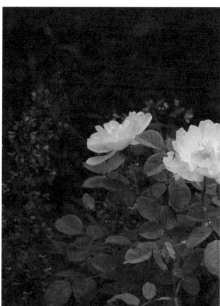
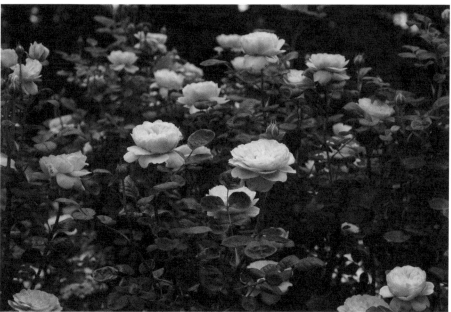

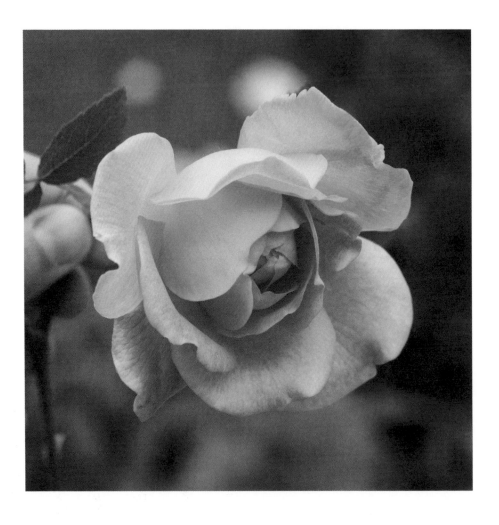

Deadheading, I sometimes think, is a way of paying homage. I snip and snip as if to say, "Yes, I see how hard you are working. Yes, I see how beautiful you are." The first flush of blooming is a heady time in the garden. It is also a mere pause before facing the rose caretaker's next challenge: pests.

Late June and July bring the Japanese beetles to my Pennsylvania garden with their exquisite iridescent green backs and a hunger that will eat through every rosebud and leaf, if I let it. Every morning I go out with a jar of soapy water and knock the still-sleepy beetles into it. Every morning, there are new beetles, like mercies I do not want. This past summer even brought a new and terrible rose-eating pest: spotted lanternfly. The nymphs with their polka-dot coats sit in rows between the thorns. I cannot catch them without stabbing myself. They laugh and suck more juice from the rose's soft, defenseless green growth. For now, spotted lanternflies are an invasive beast found only in southeastern Pennsylvania. But I am afraid that not too many years will pass before gardeners across the country meet them too.

I tend my roses with constant care, but I cannot tend away every problem or complaint. Because I refuse to use the old poisons that kept the hybrid tea roses of an earlier gardening generation blemish-free, I must accept a bit of black spot and powdery mildew or else grow no roses at all. The old cures, we now acknowledge, were worse than the disease.

I hear a murmuring query growing louder with each line I write: *Why, then, grow roses at all? Why?* And though the litany of chores has hardened my heart with each word of this essay, now my heart softens. Now a dreamy smile returns to my face. Once again I think my green and wonderful thoughts. *Why grow roses?* Ask a dancer why she dances, though her feet be battered and bruised. Ask a painter why she paints, a writer why she writes. The answer is beauty. Not prettiness. Not loveliness. But a

COMMON NAME: *rose* | **SCIENTIFIC NAME:** *Rosa*

MY FAVORITE HEIRLOOM ROSES: *'Madame Hardy', 'Albertine', 'Zephirine Drouhin' (which tolerates shade and is thornless!)*

REASONS TO LOVE ROSES: *They are the queens of the flower garden.*

REMEMBER: *One advantage of heirloom roses that only bloom in one great flush in spring is that they are not bothered by the many insect pests that plague roses in summer.*

beauty so rich and real it is almost terrifying. This is beauty with a voice. This is beauty that beckons. We will follow it no matter what, though we do not know where it will lead.

True beauty, beauty that is the language of God, is not marred by black spot, mildew, or hungry beetles. Though rain shatters the petals on the ground, beauty is not shattered. Its voice is not silenced. Though it may fade to a green thought in winter, it is a signpost of a world still to come. It is a promise that will be fulfilled.

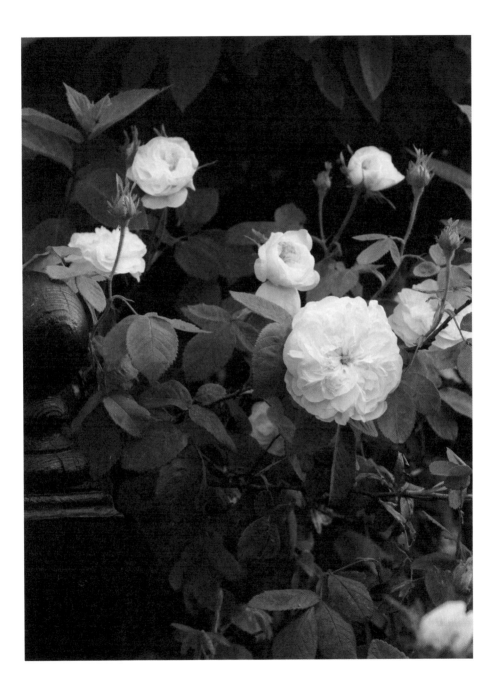

5

CELEBRATE

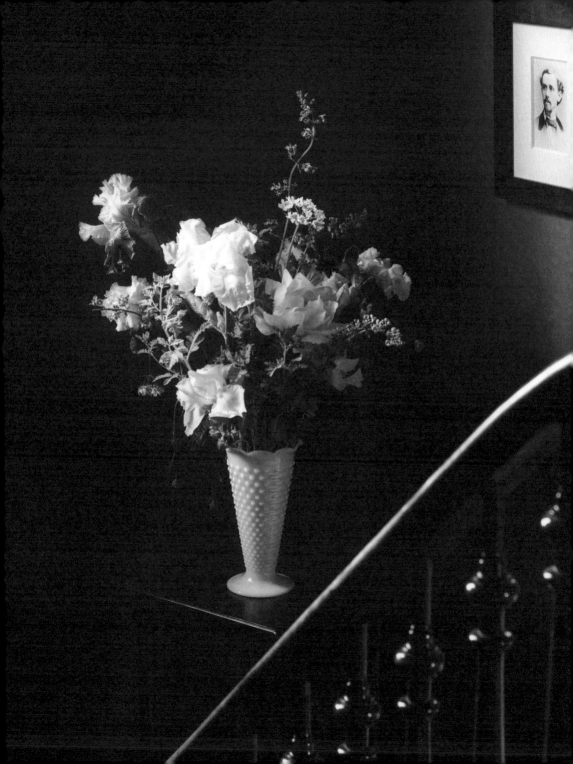

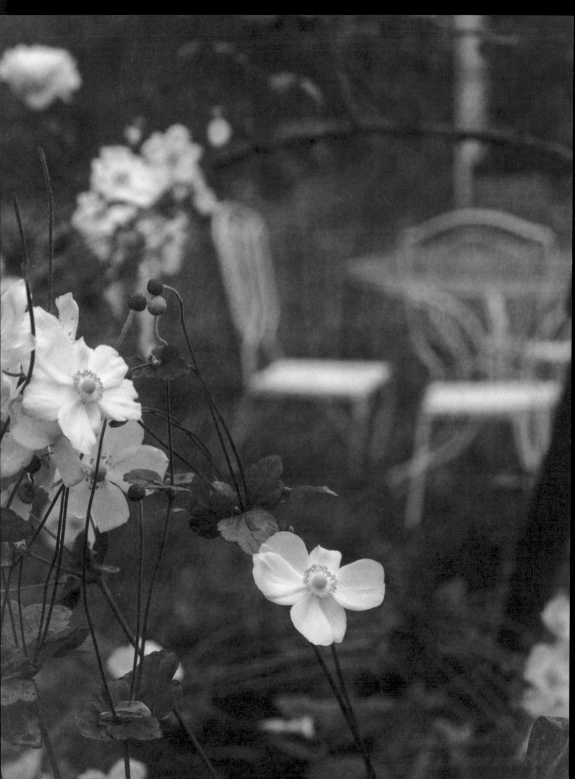

GARDEN PARTIES

BEFORE I EVER HAD A GARDEN OF MY OWN, I used to wander the old slate sidewalks of my South Side Chicago neighborhood peering over fences and peeking around shrubbery. I did not want to catch a glimpse of any people, but I did want to check on favorite plants. There was one old house in particular I loved to spy on. It sat on a rare double lot, which meant instead of a dark and narrow side yard, this house had a large grassy expanse between its own brick walls and the house next door. A large shade tree grew there. I cannot now say what kind of tree it was, but the tree was like a second home with a foundation of spreading roots, a steady trunk for walls, and a leafy, sun-dappled roof. Every time I passed that yard and that tree, I imagined the same picture in my mind—round tables draped with cloths and lanterns hanging from the tree limbs. I saw a garden party.

There are many reasons to plant a tree. Chief among them, though rarely mentioned, is our duty to secure the future of the garden party. After all,

"In my opinion, too much attention to weather makes for instability of character."

ELIZABETH GOUDGE, *THE LITTLE WHITE HORSE*

one cannot hang candlelit lanterns from the sky. First, then, anyone serious about hosting a garden party should plant a tree. Preferably a slow-growing legacy tree. Perhaps an oak or a sycamore or a sugar maple. Second, she should plant white flowers. Any white flowers will do, but scented white flowers—like oriental lilies, jasmine, nicotiana—are best. After sunset, white flowers become living lanterns. They give back the day's light long after every green leaf and grass blade submits to darkness. And the perfume of flowers is heaviest in cool evening air.

A garden party is a very particular gathering. We cannot host a garden party on a deck or porch. Those are for barbecues and iced-tea afternoons. A terrace or patio could work, but only if it is set at a distance from the house. For a garden party must take place *in* the garden. Garden parties are made when we carry the antique sofa outdoors and place it underneath the blossom-laden apple trees in spring. Garden parties are made when we mow a path through the long grass and set at the end a table with Grandmother's china. Garden parties make each participant—host and guest alike—feel as if she should be wearing a hat decked out with roses even though she is convinced she does not have the right face for hats. Garden parties are for raised pinky fingers. Tiny strawberries with fresh whipped cream. Twinkle lights and mason jars for catch-and-release firefly fun. Garden parties take frivolity and whimsy very, very seriously.

Garden parties are an act of defiance. Merely the thought of mosquitoes or buzzing bees will be enough to keep most from carrying a tray of carefully prepared deviled eggs out to the wild edges of the yard. Not many are committed enough to plug in the rarely used electric iron and tackle the linen napkins that have been folded in a drawer for at least four years. *Oh dear, perhaps they've been there for five or six. I'm quite sure we used them for our daughter's eleventh birthday tea party. She'll be turning seventeen this year.*

Garden parties are planned in defiance of wind and rain, not because we are optimists. Generally speaking, we are like Eeyore, convinced of impending doom but marching forward regardless. "No doubt our efforts will be wasted," we grumble as we pipe swirls of cream cheese into cherry tomatoes. "Why do we bother?" we moan while cutting crusts off too many tiny sandwiches. Garden parties are like gardens in this way. A great deal of effort is required. Outcomes are anything but guaranteed.

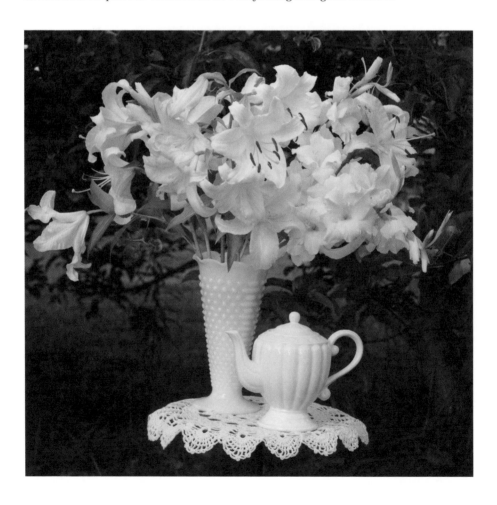

And that—discomfort, uncertainty, hard work—is soil that can grow the richest kind of celebration. Is there anything more astonishing than the blue of a sky when you felt sure it would rain? Anything sweeter than berries you sweated to pick? Or any seat more comfortable than the one you carried right up to the top of the grassy hill in order to catch the very last of the sunset colors? I'm sure there are blog posts and magazine articles with ten easy tips for a garden party. *Don't break a sweat or your budget!* the headlines reassure. And while I'm sure those parties would be lovely, they aren't really what I mean when I say the words *garden party*. They aren't really what I envisioned when I stood for too long on the cracked and heaving Chicago sidewalk, staring at that very old house with its very old tree.

What I saw all those years ago was like a table set in the wilderness. A thing of beauty snatched from the jaws of a world that values efficiency and productivity most of all. An utterly pointless, frivolous, and extravagant waste of time. Which could be—I hoped—like a moment outside of time. A taste of eternity.

Like tending a very small oak tree. Or sycamore. Or sugar maple.

Like planting a seed.

Like sending an invitation.

It should go without saying, yet I sense it must be said: A garden party is rooted in a garden the way a tree is rooted in the ground. One gives birth to the other, but we cannot say with certainty which is more important. Do we plan garden parties because we have a garden? Or do we, as I suspect, grow gardens because only flowers tended over months and trees tended over decades can give the proper foundation for a party that is less like any other party and more like an encounter of heaven and earth?

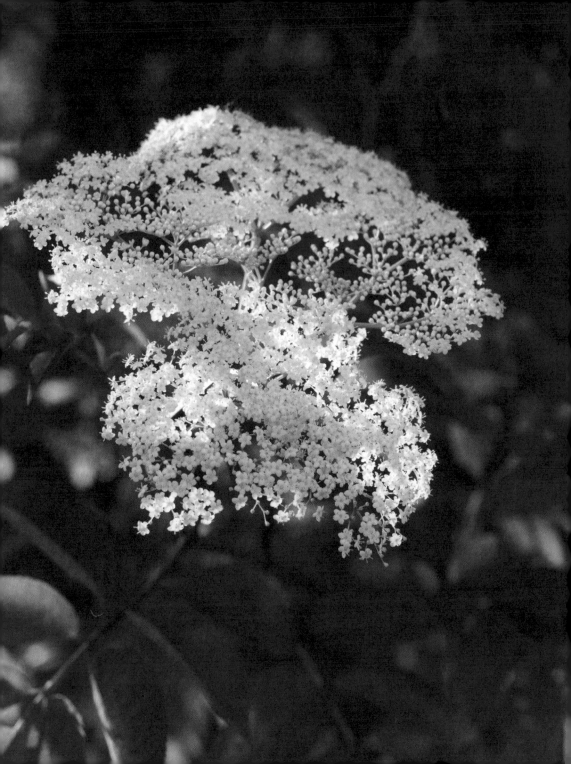

ELDERFLOWER "CHAMPAGNE"

In the old stories the gods drink mead. I can't recall any stories about what the fairies drink, but my money is on elderflower champagne. Made with the blossoms of Sambucus nigra *or* Sambucus canadensis, *it is only lightly alcoholic and tastes like summer sunshine shot through with floral bubbles.*

GATHER

8 large flower heads
 (around six inches across, or double
 the number of smaller flowers)

2 pints boiling water (non-chlorinated)

6 pints cold water (non-chlorinated)

1 pound honey
 (or 1 ½ pounds granulated sugar)

2 large lemons (juice and rind)

2 tablespoons cider vinegar

MAKE

1. DO NOT wash the flowers. They are coated in a naturally occurring yeast which will help the mixture to ferment. Shake off any insects and cut out the thick stems.

2. Place the honey or sugar in a large bowl and cover with the boiling water. Stir until the sweetener has dissolved.

3. Add the cold water, then stir in lemon juice, rind, and elderflowers.

4. Cover with a dish towel and let sit for 48 hours, stirring twice each day. By the end of the second day, signs of fermentation, such as bubbles and froth, should become apparent, especially when the mixture is stirred. If the mixture remains entirely still after 48 hours, add the smallest pinch of baking yeast and let sit for another 48 hours, stirring occasionally.

5. Pour the fermenting champagne through a fine sieve, straining out the flowers and lemon rind. Using a funnel, transfer the liquid into clean, plastic soda bottles with screw top lids or thick, glass beer bottles with flip tops. Leave an inch of headspace between the liquid and the top when securing your lids.

6. Leave at room temperature for one week, "burping" the bottles at least once a day to let some of the air escape. Move to the refrigerator but continue burping the bottles for another week or so. Your champagne should be fizzy and sweet but not too sweet.

7. Drink and celebrate! Elderflower champagne will keep for several months refrigerated. The best flavor is around two weeks after bottling.

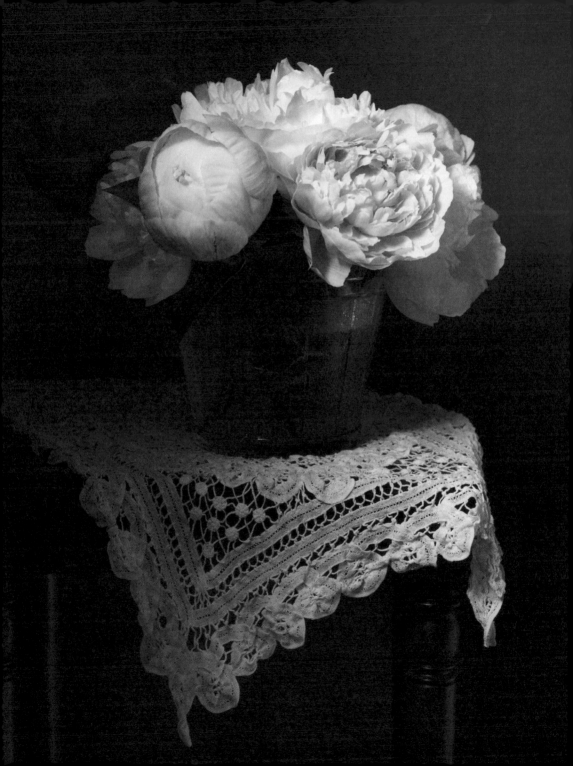

PEONIES

Celebration and Commemoration

PEONIES ARE ALWAYS FULLY THEMSELVES. We never mistake them for some other flower. No one ever says, "Oh, that peony looks just like a double-flowering tulip!" Instead we admire *Tulipa* 'Dream Touch' by exclaiming, "It looks just like a peony!" Even a daylily with extra ruffled petals has been named 'Siloam Peony Display'. Peonies are icons. They are archetypes. They are reliably themselves. But what is it they are the essence of? What is the story they tell? In my own country, peonies, blooming as they do in late spring, are the traditional flower for decorating gravesites on Memorial Day. And you often find them planted in cemeteries. In Greek mythology, they take their name from Paeon, who once healed Hades's and Ares's wounds.

I imagine the Victorians included whole chapters on "cemetery gardening" in their garden books. But we have quite successfully banished grief from our lives and our gardens. Dying proceeds in hospitals. It leaves no lingering trace in the pristine spaces of our homes. Death is sometimes marked in an old-fashioned way. We do still carve stones. We do still bring flowers. But the ancient words *requiescat in pace* have been abbreviated

"The fattest and most scrumptious of all flowers, a rare fusion of fluff and majesty, the peony is now coming into bloom."

HENRY MITCHELL

and largely limited to Halloween decor. In our modern nomadic culture, many of us follow the trail of job offers and changes of scene until the gravestones that matter, the ones we still see with our mind's eye, lie miles away. We cannot plant peonies. We cannot take our children and tell them stories of the ones we knew and loved.

Our garden books do not directly address death. They offer practical gardening techniques, giving them misleadingly neutral names like *layered gardening* or *four-season gardening*. Following this advice, we cheerfully interplant our tulips and daffodils with shallow-rooted perennials. Now we need no longer be assaulted by the dying bulb foliage. Death is always camouflaged by the next blooming plant. Yet grief still finds us. It winds its way in on unexpected garden paths. An ancient tree falls, and we are surprised, embarrassed even, by our heavy hearts, by our tears.

Still, there is always something to anticipate. We need not look back. The great empty space left by the tree is terrible, but now there is sunshine for daffodils. Then lilac. Then azaleas. And peonies! And roses! And after? Hydrangeas, daylilies, and more. There is no need to mourn the passing of the tree. But if the gaps still find you, if the empty space in your yard or flower bed haunts your sleep even in the midst of summer's blooming bounty, well, the horticulturists can help. They have tinkered and fiddled (plotted and potted), and now you can purchase the solution to your sorrow. Every plant has its reblooming variety. Reblooming lilac. Reblooming azaleas. Reblooming roses. Reblooming daylilies. So dry your eyes. Take up your nursery catalog. Look for words like *boomerang* and *knockout*. Because even in the garden we need never say goodbye. We need never sit in quietness waiting for the return of every beautiful thing we have loved and lost.

Except for the peonies. They are icons, they are archetypes, and they are stubborn. They have never submitted to the modern demand for seasonless

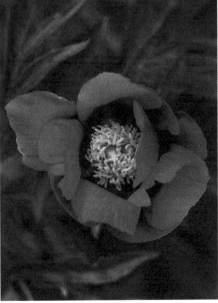

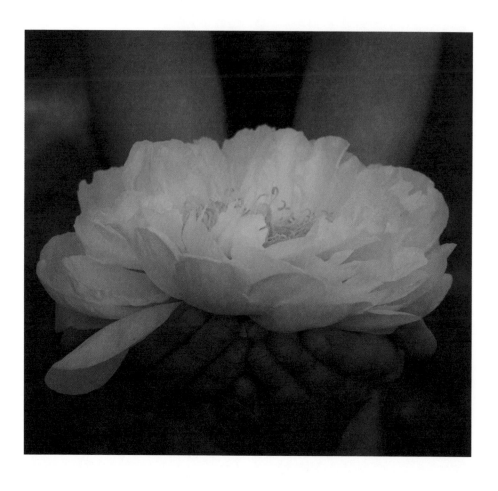

flowers. For months we anticipate them, for weeks we revel in them, and when they are gone, we miss them. I consider it a saving grace that peonies are best planted as bare roots in fall. That means I need not wait long to plant new ones, and I can soothe my summer grief by studying the varieties offered in catalogs. It turns out that icons come in many shapes, scents, and colors.

There are the ruffled cream puff peonies we all know and love. 'Sarah Bernhardt' is my favorite. It looks like strawberry ice cream and smells even better. There are the exquisite single peonies that look like they returned to life after wintering on a Ming dynasty porcelain jar. I love these peonies for their early blooms and the way they hold up without support even in a rainstorm. There are also wonderful hybrid peonies that cross the usual herbaceous types (those that die back to the ground each winter) with tree peonies (woody shrubs that do not die back). These intersectional peonies, or Itoh peonies, are named for their creator, Japanese horticulturalist Dr. Toichi Itoh. The shrubs are strong and require no support, and the blooms are simply stunning. My yellow 'Bartzella' intersectional peony covers itself in lemony flowers larger than my teenage daughter's cupped hands.

The arts of the tightrope walker or the juggler who tosses flames are rightly called death-defying. Their efforts are death-defying not only because they are dangerous but because they sustain something that would—for most of us—fall apart almost immediately. I could take a few steps along a taut cable, but the trained performer can take many. I might be able to toss lit torches into the air and catch them, but I'm sure I couldn't do it more than once. In a similar way, the efforts of the gardener are death-defying. Even a child can plant a seed and watch it grow, but a gardener plants seeds and orchestrates a living, growing work of art that, as some flowers fade and others take their place, appears to defy death for months on end.

COMMON NAME: *peony* | **SCIENTIFIC NAME:** *Paeonia*

MY FAVORITES: *'Sarah Bernhardt', 'Bartzella', and 'Kansas'*

REASONS TO LOVE PEONIES: *They are an unforgettable highlight of the late spring garden.*

REMEMBER: *Peonies are one of the longest-lived perennials we can grow. It is worth seeking out heirloom varieties for their wonderful scent. Peonies are best planted as bare roots in the fall, but peonies already growing in pots can be added to the garden in spring.*

There is nothing death-defying about the row of peonies that grow in a straight line against the black picket fence of my flower garden. On their own, they do not dazzle with months of carefully orchestrated blooms. Yet just as Paeon once healed the wounds of Death and War, the genus *Paeonia* is well suited to do the same. Peonies are good medicine for grief, not because they deny death and suffering, the way those reblooming wonders can sometimes seem to do. They are some of the longest-lived of our garden perennials, and springtime after springtime, they flower for us before fading into the general green of summer. They are not a circus act. They are worthy of being painted on fine porcelain. They are worthy of honoring the graves of our dead. No one ever took a peony for granted. No one ever said, "Oh, I will come back and admire you tomorrow." Peonies are only for right now—which means that peonies are forever.

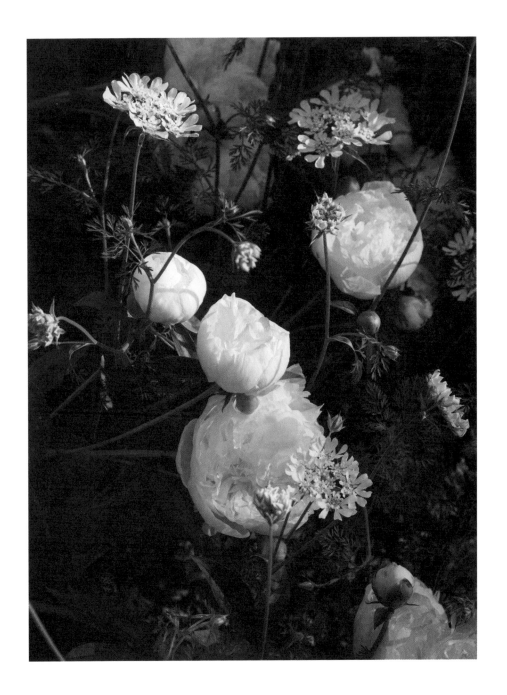

FLOWER CROWNS

While crowns of woven leaves and flowers are most often associated with victory and power in the ancient world, Queen Victoria secured a more celebratory connotation when she wore a crown of orange blossoms for her wedding to Prince Albert. But symbols are personal as well as historical. Thinking perhaps of the daisy chains of childhood, I associate flower crowns with whimsy and imagination. To me, they are an utterly serious flight of fancy. A lovely contradiction. A paradox both beautiful and true.

GATHER

flowers
greenery
floral wire
floral tape
wire snips

MAKE

Take a piece of wire and form it into a circle the right size for the recipient's head. Either tape the circle shut with floral tape, wrapping several times around, or form the wire into one loop and one hook to secure.

Use floral tape to attach a base of greenery to the wire. Secure small bundles of flowers with tape before adding them to the wire circle with more tape, wrapping around four or five times (floral tape secures itself when it is pulled and stretched).

Use these directions as a starting point for your own imaginative and deeply meaningful floral flight of fancy.

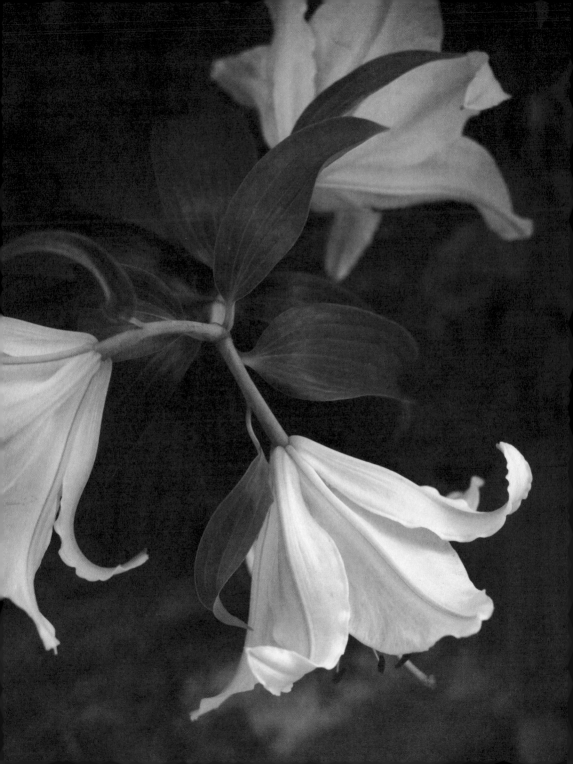

LILY LANTERNS

THERE ARE FAIRY FLOWERS AND THEN THERE ARE
faerie flowers. The difference isn't really one of etymology or extra vowels.
It is more like the difference between a Disney princess movie and a tale by
the Brothers Grimm. One is sweet and dainty. The other beautiful but ter-
rifying. Fairy flowers are the tiny things my firstborn and I collected in a
china thimble for the dollhouse. Wild strawberry blossom and sweet alys-
sum make a just-right bouquet for the dolls' dining room table. Faerie flow-
ers are the scented oriental lilies in a crystal vase on my own dining room
table. They are overpowering. Otherworldly. A little too much in every way.

My firstborn, my older daughter, is named for the lily. My Lily loved mer-
maids when she was young, but she loved cartoon mermaids. We read a
mermaid story together—I've forgotten the name—but I remember it was
based in Scottish legend. The mermaid in that story was neither hero-
ine nor villain. She was dangerous and frightening but only because she
was vain and selfish. She was enticing but overwhelming. She was other-
worldly. Lily did not care for her one bit. She was "scary," my daughter said.
She wasn't "nice."

*"The only words that ever satisfied me as describing Nature are the
terms used in the fairy books, 'charm,' 'spell,' 'enchantment.' They
express the arbitrariness of the fact and its mystery. A tree grows
fruit because it is a magic tree."*

G.K. CHESTERTON, *ORTHODOXY*

Friends have often confided to me that they find the scent of perfumed lilies to be "too much." One friend told me, "I can't have them in the house." Scented lilies are not cartoon flowers. Like the mermaids of legend, they are too much. For those who cannot "have them in the house," or the garden, there are other "lilies" to choose from—daylilies, for one. Daylilies are tough and reliable garden plants, though they become like something enchanted when you cut them for a vase. Aptly named, daylily blooms fade at midnight, like a coach turned pumpkin. There are quite a few flowers with the common name *spider lily*. Now *that* certainly sounds like something from a fairy tale. There are calla lilies (*Zantedeschia aethiopica*) and canna lilies (*Cannaceae*). Both of those do well in warm climates. There is lily of the valley (*Convallaria majalis*), which may be the epitome of a fairy flower. But above all these, there is the genus *Lilium* itself.

In my own garden, the *Lilium* parade begins with a striking flower called 'Eyeliner', one of the hybrid Asiatic lilies. These flowers usually lack scent and stature and can be somewhat stiff and garish for my taste, almost like faux flower versions of themselves. But I have found varieties I like: 'Eyeliner' is white with a mysterious black edge, and 'Netty's Pride' offers the vivid contrast of white and burgundy. They are worth growing as a kind of garden appetizer—lovely for themselves while whetting one's appetite for the main course still to come. Next for me are the trumpet lilies, *Lilium regale*. This species of wild trumpet lily is dark pink when closed, but it opens to show white petals and a golden yellow throat. A child who ventures into a patch of trumpet lilies might need bread crumbs to find her way out again. They make a pink and perfumed faerie forest.

Trumpet lilies are the bridge between early Asiatics and Oriental lilies. Flowers of *Lilium orientalis*, like the famous pure white 'Casablanca' or the speckled, deep pink 'Star Gazer', are tall and strongly scented. Inevitably, I

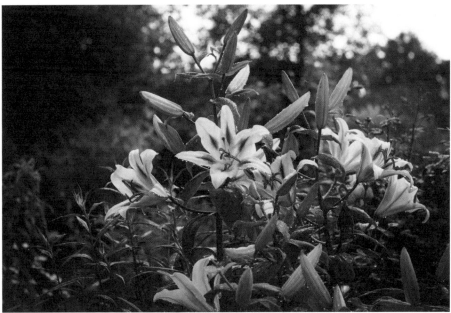

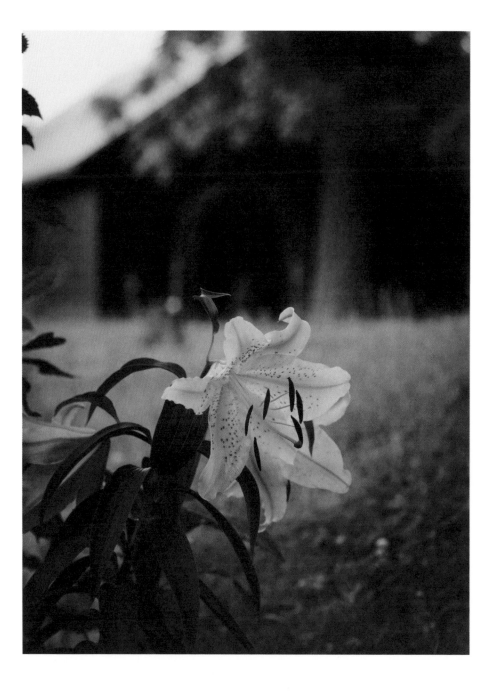

neglect to stake them, and they topple over in a rainstorm as if to say I am unworthy of them. And they are right. I *am* unworthy, but I cut the broken stems and bring them inside to fill my home with a scent that is "not nice." It is less like scented candles and body lotion, more like heaven's "golden bowls of incense" from the book of Revelation. It is altogether too much, and I adore it.

When plant breeders crossed Oriental lilies and trumpet lilies, they created something called an "Orienpet," which sounds cozy and cute, like an animal for a handbag, but is actually represented by a seven-foot stunner called 'Black Beauty'. I love this lily for its rich scent and richer color, but I especially love it for its recurved petals. Unlike the stiff and flat faces of an Asiatic lily, 'Black Beauty' has petals that curl back from its face like a wild strand of Goldilocks's hair. If you aren't already running outdoors to dig a deep hole for a lily bulb, you soon will be if I tell you about Madonna lilies (*Lilium candidum*) or Formosa lilies (*Lilium formosanum*). And how could I leave out the tiger lily (*Lilium lancifolium*)? There is also my new favorite lily, an 1862 heirloom called the gold band lily (*Lilium auratum* var. *platyphyllum*). Apparently, this was the "Queen" of Victorian gardens, and like any other proper society queen of the Victorian age, she had her portrait painted by John Singer Sargent.

The Victorians loved fairy stories. In an age of smokestacks and steam engines and religion with more piety than mystery, they found in the poetry of Tennyson or the tales of George MacDonald a doorway to more inscrutable spiritual realities. I think they may have found the same in their gardens. Not every garden, mind you. Staid Victorian landscaping of red geraniums and "carpet bedding," like the municipal plantings of today, were probably more common than lily bowers. Even in our own technological age, more of us grow lawn grass with the aid of chemicals

COMMON NAME: *lily* | **SCIENTIFIC NAME:** *Lilium*

MY FAVORITES: *'Casa Blanca', 'Gold Band', and 'Black Beauty'*

REASONS TO LOVE LILIES: *They are exquisite and require little care.*

REMEMBER: *Lilies can be planted as bulbs in spring or fall, depending on the variety.*

than faerie flowers like the lily. Our lives, then and now, are written in prose, but some gardens and some flowers are poetry. Scented, statuesque lilies are flowers of celebration but perhaps not in the way we typically use that word. With their overwhelming perfume, these are not flowers for a dinner party. Instead, they are flowers that celebrate—in other words, acknowledge—the mysterious depths of our own selves and this world in which we dwell. These flowers are a doorway. Dare we enter in?

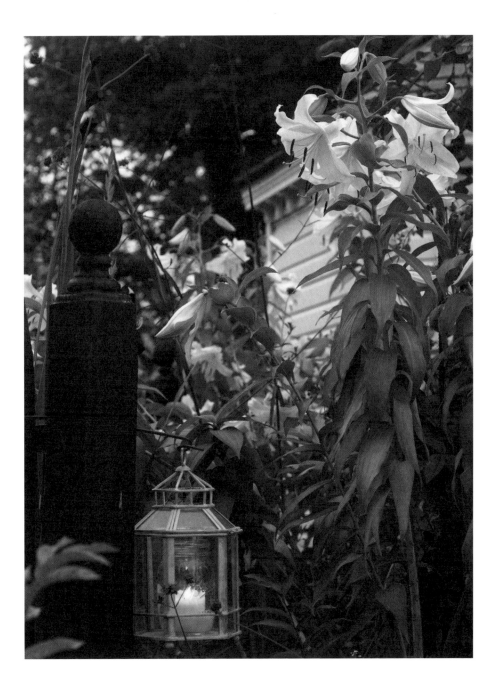

6

HARVEST

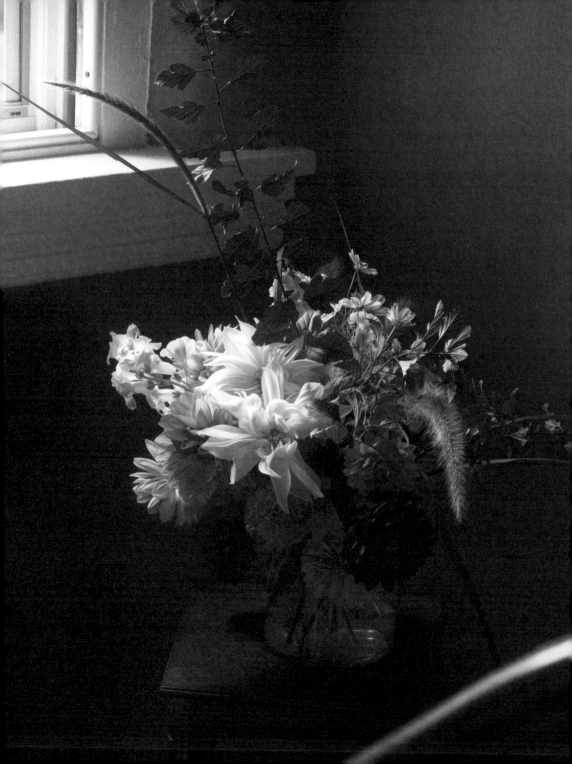

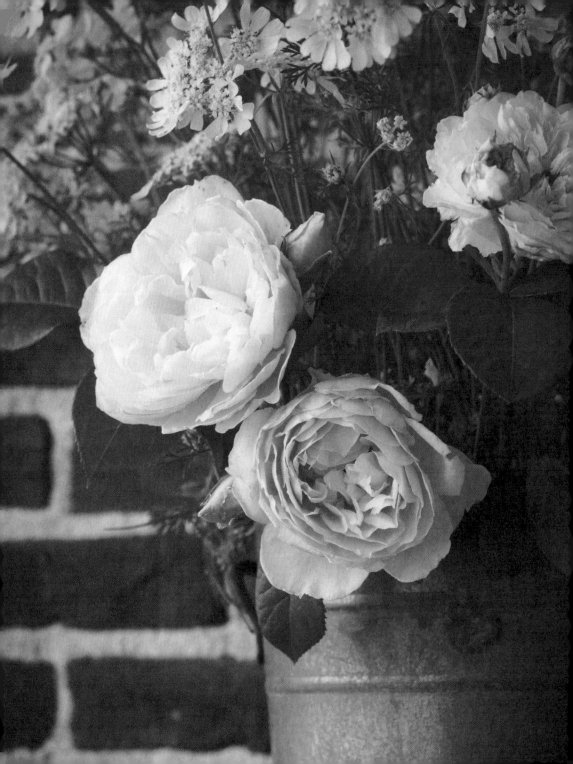

FLOWERS OF IMPORTANCE

THERE IS A MOMENT EARLY IN VIRGINIA WOOLF'S novel *The Waves* in which the characters, as children, play in a garden. In their imaginations it is a wild, undiscovered country or it is a fairyland for elves, but no matter what they imagine, their play must account for the lady "who sits between the two long windows, writing" while "the gardeners sweep the lawn with giant brooms." In this world, even the expansive imagination of childhood offers only a partial escape from a world of class traditions and proper behavior that will soon claim the children for its own. In Woolf's novel, "gardeners sweeping" becomes a refrain as enduring and unshakeable as the waves crashing on the shore.

The proper nineteenth-century English world depicted and dissected in Woolf's early-twentieth-century fiction is a world in which ladies "do" the flowers. Possibly Woolf's most famous novel begins with preparations for a party and the line "Mrs. Dalloway said she would buy the flowers

"Yet she had been unable to read, had scattered unfinished letters over her table, done the flowers atrociously. Sweet peas had spun and trembled between her fingers from their very importance."

ELIZABETH BOWEN, *THE LAST SEPTEMBER*

herself." And in *To the Lighthouse*, Mrs. Ramsay, a character inspired by Woolf's own mother, "studies the flowers" and frets over whether to send flowering bulbs to the gardener in fall, while her husband, preoccupied with his work, "did not look at the flowers, which his wife was considering, but at a spot a foot or so above them." In so many novels, women of a certain class busy themselves with flowers because they are not allowed to busy themselves with more "important" work. Why, then, in a twenty-first-century world of endless choice, would anyone, man or woman, spend time arranging flowers?

Flower arranging is a pointless art, and that, dear reader, is precisely the point. What was once an emblem of narrow and circumscribed social roles has become an act of rebellion against the cultural mandate of personal productivity—though, if I am being honest, it is a rebellion I often can't be bothered to fight. Instead, I plunk a handful of zinnias in a mason jar and call it *good enough*. Or I tell myself the delicate 'Lady of Shalott' roses look perfectly at home in a jar with a half-torn label proclaiming the very best in Kalamata olives.

But sometimes I stand with Dostoevsky, and I behave as if beauty might just save the world. Sometimes I cut my flowers with a little more care and attention (because the burgundy of the ninebark leaves seems exactly right for the dusty pink of the 'Gentle Hermione' roses), and I choose a real (rather than recycled) vessel. Sometimes I bother to pull out the tools that really do make a difference: the flower frogs (a silly name for a life-changing object) and flower tape, the sharp snips and the specially made flower water. And I give my time and attention to an art form of exquisite, maddening ephemerality. For like sandcastles or ice sculptures, flower arrangements are creativity at its most momentary and nonutilitarian. Of course, as this book testifies, I also love using my

camera to "capture" the moment before it disappears completely into the realm of memory.

Like every art, the art of floral arrangement has its tools and techniques. I snubbed them for years (and, if I'm honest, do still snub that icky, and apparently toxic, green foam). But then I tried a flower frog and played with floral tape and discovered that a whole new world of possibility had quickly and easily opened. Now I have *two* flower frogs, and a cabinet full of green *and* clear floral tape. I have special little snips that I only use for cutting flowers (and which I keep on a very high shelf so no one else steals them for crafting a cardboard fort), and I have collected real vases in all sorts of sizes and materials. Thankfully, these are inexpensive and also recycled, in a way, as I find them all at local thrift stores and secondhand shops. Too many of us seem to have little space left in our lives or our cupboards for "fancy" things. This means that thrift shops are usually bursting with Grandmother's fine china teacups and flower vases in cut crystal or faceted milk glass.

As has become abundantly clear, I am no professional arranger, nor do I have ambitions to be. But I have learned to keep two things top of mind when arranging with more than my usual effort—structure and appearance. By *structure* I simply mean holding the flowers in some way that helps them look their best. Flower frogs, like little metal pincushions, are invaluable here. They can hold even the heavy-headed stems of peony blooms in suspended animation. Chicken wire, balled up and pushed into the vase, also works wonders. Or a grid of tape laid crisscross over the top of a vase can help hold the stems just so. By *appearance* I mean the look of the thing—the colors, the shapes, the movement. Single color arrangements, especially in a range of shades, are a good idea, though they can be harder to get right than we might expect. It is important to study color *and*

tone, as a cool-toned pink and a warm-toned pink might clash rather than meld. Simple contrasts are fun to play with, especially when we pull from opposite sides of the color wheel: purple with orange, perhaps, or red roses with lots of deep green leaves.

One lesson I've learned has proven helpful for the design of vase and garden. While my eye goes to the flower, while my mind is obsessed with blooms, what I actually need is anything that can politely be called "filler." In other words, it's all about the backdrop. While I once jammed flower beds with roses, I now prefer to highlight a special rose against a running thread of feathery grass. And I can't tell you how many times I've gathered a bucket of blooms and begun arranging them, only to head back out in search of fern fronds, hosta leaves, ornamental grass clippings, and anything else suitable for setting off the flowers the way a gold band sets off a diamond. But then again, who has ever seen a diamond as lovely as one white cosmos? The papery petals of a cosmos cannot etch glass, and they will not last. But I think this makes them more, not less, precious.

MY EASIEST BOUQUET RECIPES

ONE FLOWER / ONE COLOR

When we think *bouquet*, we usually picture a mixed bouquet. But one of the easiest ways to create a strong statement with your homegrown flowers is simply to cut masses of one thing and pack them into a complementary container. I love bright zinnias in a mason jar, pillowy roses in a rounded glass vase, and bunches of daisylike feverfew in a galvanized bucket.

SINGLE BLOSSOMS / MANY CONTAINERS

Arranging flowers and filler in combination is an art form. It's an art form worth learning, but while we're gaining knowledge and perfecting our skill, an easy shortcut is to cut a multitude of flowers and place them in individual bottles and jars. I keep beautiful old wine bottles for just this kind of arrangement and love lining up a row of single roses or dahlias or daffodils down the dining room table.

WILD SHADES OF ONE COLOR

Creating an arrangement of flowers is almost like gathering up a mini-garden, but mixed bouquets can quickly look messy. I rein in the messiness while celebrating the wild diversity of my garden by choosing a mixture of flowers and plants in a variety of shapes (for instance, fat, round roses with long, reaching panicles of grass) but limiting them to shades of a single color.

In spring, I might gather pale pink roses and mauve verbascum with burgundy ninebark leaves. At the end of the season, there are more pink roses, but this time I add the soft purple-pink flowers of purple fountain grass and burgundy-leaved branches from a sand cherry shrub.

SUPERHERO
SHRUBS

IT HAS BEEN SAID THE LONGER ONE GARDENS THE more enthusiastic one becomes about shrubs. When I began gardening, my favorite bedtime reading was a catalog with row after row of tempting floral portraits. Now I keep my encyclopedia of trees and shrubs closest. Bushes and branches are the stuff of my dreams these days. I have learned that shrubs *make* a garden, and they do this while asking almost nothing from us. They give the structure. They provide the necessary backdrop. They screen out undesirable views. They filter wind and noise. They anchor even the smallest flower bed. They immediately fill out a beautiful container. Also—I have learned—they make the most surprising and stunning flower arrangements. And in exchange? We should water them well the first year after we plant them. Some benefit from pruning once a year. Otherwise, leave them be, and they will become your garden. Instantly. Easily. Leaving us so much more time to fuss about with little flowers at our feet.

"Although I spent a good deal of my childhood out of doors,
I cannot remember ever noticing the twigs of any trees in winter. . . .
Now I am grown up, however, the sight of winter twigs, shorn
of their masking leaves, affects me deeply."

URSULA BUCHAN, *BACK TO THE GARDEN*

Flowering shrubs are, I suppose, a gateway shrub for flower lovers. For a few weeks each year, no one would call them invisible or boring. Azaleas entice the color lover by painting the edges of our woods. Blooming viburnums draw us in with sweet floral scent. Lilacs are an icon more powerful than Proust's madeleine cookie for arousing long-buried memories. By comparison, boxwood might seem to be a dull thing. Once this was a shrub I almost couldn't see. It was simply *there* like a green moustache at the foundation of every suburban house. But now I covet these ordinary suburban shrubs. I see fresh green clippings for a wreath. I see emerald-green eye candy for sustaining us through long winters. I see history and topiary and an excuse to buy those fancy hand shears from Japan.

The pink and blue mophead flowers of some hydrangeas were never so invisible. They speak to me of the south and of the seaside. Here at Maplehurst, two inland hours from the sea and north of the Mason-Dixon, a particularly famous mophead hydrangea is jokingly called 'Endless Bummer' for its refusal to bloom after a cold winter. Lesser known, often invisible hydrangeas are the stars in my garden. I love the native oakleaf hydrangeas with leaves that turn a simmering burgundy-red in the fall. I love the panicle types that first flower in fresh white before aging over the summer months to glorious maroon. Panicle hydrangeas like the tall 'Limelight' make substantial and elegant hedges. They also make great cut flowers. The trick is to let flowers from 'Limelight' or 'Fire Light' age a bit on the shrub. Cut them and place them in a small amount of water, but do not add water. When the water has evaporated, the hydrangea is dry and prepared to look beautiful all winter long.

Just as shrubs have superseded flowers in importance over the years of my gardening life, so the flowers of a shrub have also begun to consume less of my attention. Ninebark is a good example of this. The spring flowers

are wonderful, but the wonder is in the contrast of the pale pink starry flowerheads with the deep burgundy of the leaves. When the flowers do fade, the leaves are still there, pulsing with rich, royal color. There is no sadness for me when the ninebark flowers fade.

I have lately taken my love of shrubbery to new heights. This fall I perused the endless rows of mushroomlike mums at the local farm stands and grocery stores with dismay. Like button mushrooms in candy corn colors, the mums said *fall*, but they didn't say anything else. It seems my own flower garden has grown in me a more sophisticated palette, and I realized that I wanted the flowerpots on my front steps to be as wildly pretty as my garden. But how to accomplish this? The mums were no use to me, and the other fall annuals were similarly predictable. But when I left the annual aisle and wandered a row of discounted perennials, I found just what I needed: purpleleaf sand cherry, with its strange name and beautiful plum-purple leaves. While the shrubs cost as much as three or four mums, I knew that not only would they look better in my pots now, but I wouldn't have to toss them on the compost heap at the turning of the season. Instead, I have left them in a sheltered place, and I am hopeful that spring will find me planting them out in some sunny spot. They will glow in purple splendor on the edge of my garden, invisible, perhaps, to everyone but me. They will be my secret delight.

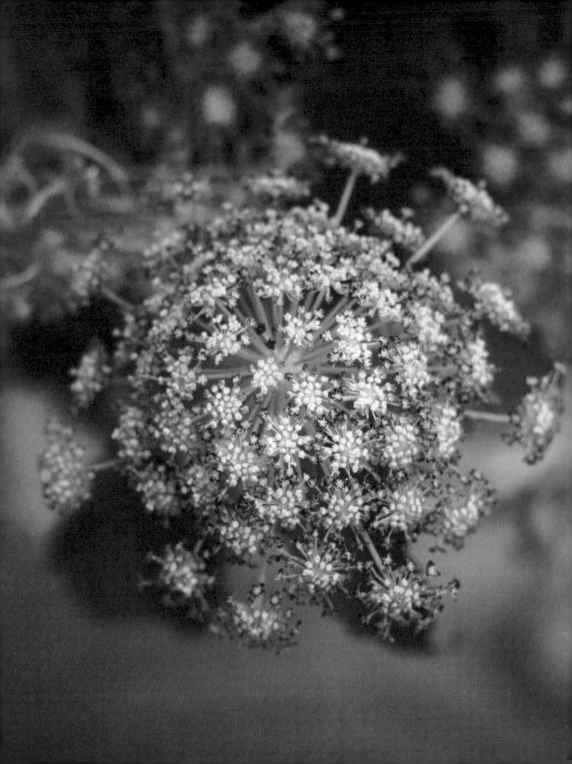

SELF-SOWING SALVATION

I RECENTLY READ A PICTURE-BOOK VERSION OF Aesop's fables with my youngest and realized my sympathies were entirely with the lazy grasshopper rather than the industrious ant. I am an enthusiastic gardener but not a very diligent one. I leave my iris clumps undivided for far too long. I forget to tidy up the dying peony foliage in fall, leaving my precious peonies at greater risk for disease. I grow edible nasturtium flowers for the purpose of adding spicy petals to my salads then stand admiring them without ever remembering to pick them. When I do manage to harvest the gorgeous black-green leaves of the Tuscan kale, blanch them in boiling water, and stash them—neatly labeled—in my freezer, I am all too likely to find that same kale buried beneath ancient frozen bananas three years later, still neatly labeled but now decorated with a mournful shroud of ice.

Aesop would not approve of my garden methods. Likely, he would call them madness. But what if the grasshopper was only a misunderstood artist? After all, he carried a fiddle under his arm and spent the warm summer months making music. Summer's sonic glory would be noticeably dimmed if we had only the ants for company. There is a time for work and a

"The depth and richness of God's love are staggering and incomprehensible. Although we pull away and even try to de-create the world, God continually comes to us, recreating the world anew."

FRED BAHNSON AND NORMAN WIRZBA, *MAKING PEACE WITH THE LAND*

time for play, Aesop tells us, but what if art is the meeting place of the two? The grasshopper appeared to be lazy, whiling away the warm weather with song, but I like to imagine he was only entranced by the beauty of the moment as I am captivated by each successive flower in my garden. Is it so wrong to look and listen so attentively that we risk slowing down the too-busy pace of modern life?

Fortunately for me, there is a kind of harvest that happens naturally in the flower garden, as if nature offered some middle path. Garden makers who grow self-seeding flowers can enjoy the beautiful moment *and* reap a harvest of new garden plants. Every year with little effort I harvest these flower seeds: *Verbena bonariensis*, chocolate lace flower, and my favorite poppy, 'Lauren's Grape'. Thanks to the wind and my own occasional helping hands, these have become signature flowers in my garden, and every year I have more of them to enjoy.

The rose may be the queen in the gardens here at Maplehurst, but *Verbena bonariensis* is her faithful lady-in-waiting. Verbena's airy, frothy purple flowers dance in the wind on tall, slender stems, getting in no one's way and making every other plant look somehow even more alive. This is the purple ribbon that weaves its way in and out of every part of my garden, yet it all came from a single packet of seed. *Verbena bonariensis* is not perennial in my Zone 6 garden. Occasionally, after a mild winter or if a particular plant is well mulched, it will resprout from the roots. But for the most part, this year's verbena plants will not return next year. Their children will.

Every purple flower dries into seed, drops its seeds on the ground, and waits for spring. This is the definition of a "self-seeding" or "self-sowing" plant. And I can help the process along if I like. In early autumn I snap off seedheads and scatter them in the places I want them to grow. Sometimes I tuck a few handfuls into a paper bag or envelope and save them to scatter

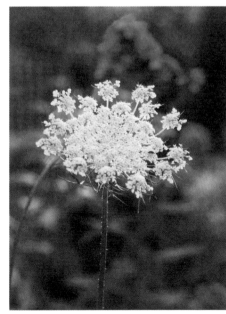

next spring. In these ways, I partner with the wind and participate in a harvest that will explode into flower next spring.

Verbena bonariensis gives the longest lasting color in my garden. It gives movement. It encourages that delicate, meadowlike beauty I particularly love. At most, I need only thin the seedlings if they grow in too thickly. Chocolate lace flowers, or *Daucus carota* 'Dara', are less of an "all-rounder," as my favorite television gardening guru Monty Don would say. The flowers are slower to bloom, tend to crowd out other plants, and turn to brown seedheads much more quickly. But I don't mind. The frothy blend of their purple, pink, and brown umbel-shaped flowers is my idea of a meadow in heaven. They are aggressive and assertive, and I am willingly and happily their humble servant.

The flowers of those purple poppies known as 'Lauren's Grape' come and go like the lilies of the field, but they, too, would give Solomon's glory a run for its money. Even the dried seedheads—with their poppy seeds rattling as if in a fairy's drum—add a sculptural beauty to the flower border. If I want to harvest these seeds, I must only be careful that I do not loose them all from their little drum when I snap the stem. Poppy seeds *want* to spill.

Seed spiller. Seed saver. What really is the difference in the end? The wind does it. Children playing do it. Even the busy squirrel, burying his acorn bounty, does it, though for different purposes than mine. Dear Aesop, in your eagerness to impart a moral, I fear you have neglected the third way. When confronted with a fork in the road, there is usually a middle path, if we search for it. In June and July, I will be the grasshopper dancing to the music with my dancing purple flowers. In August and September, I will go on dancing, but I will dance with seeds in my hands. Next spring, my footsteps will still be visible, this time outlined with new plants.

MULTIPLY

HIGHER-LEVEL MATH

THERE IS A GREAT DEAL OF MATHEMATICS IN the garden. Fortunately for me, it is the kind of mysterious, slightly mystical math where two and two are more than four and plants are multiplied through division. I can bring home two daylilies from the garden center, and fifteen minutes later, with the help of my Japanese hori hori garden knife, I have planted six daylilies in the soil. Over the years, I have learned to slice root balls into pieces as if they were loaves and fishes. It's just another day in the garden. Just another ordinary miracle.

As it is with other miracles, it is liberating, a kind of freedom from bondage, in a small way. No longer dependent on the garden center for every plant it will take to fill my beds and borders, I have become like a magician, pulling plants rather than rabbits from my hat. I admit I did not always see it this way. For many years, I avoided even planting those perennials my garden books informed me would need dividing every three to five years in order to stay healthy. I thought of division as a chore, and I did not relish it. I would rather plant things that could look after themselves. No rosebush

"Miracles are a retelling in small letters of the very same story which is written across the whole world in letters too large for some of us to see."

C.S. LEWIS, *MIRACLES*

ever needed to be dug up and divided; they just got on with the business of growing flowers. My kind of plant, that.

How little I understood the generosity of flowering perennials like catmint and iris, daylily and hosta. What seemed a burden placed on me, the gardener, was a gift of the garden I refused to receive for too long. Fortunately, my first real experience with digging up and dividing one plant into two or more came about almost accidentally. When we moved to Maplehurst, our wraparound front porch was edged with hostas. I am not the biggest fan of these tropical-leaved, shade-loving plants, but this particular variety released the loveliest tall white flowers every August. They had the most intoxicating evening scent. I ignored these hostas for most of the year, but in August I always knelt, at least for a moment, before their scented glory.

When it became necessary to rebuild our front porch and replace the rotting wooden steps with brick steps, we decided to raise the soil level around the house. This meant digging out the hostas and moving them to some other spot in the garden. However, these particular hostas had been growing far longer than the recommended three to five years. They were enormous, and it was not possible to heave them out of the soil in one piece, let alone cart their cast-iron root balls somewhere else. By necessity, I split the hostas into pieces in order to lever them out of the dirt. One-third or one-fourth of a hosta was all I could hold in my arms before plunking them into my wheelbarrow.

As I shoved bits of hosta into holes hastily dug, it seemed unlikely my efforts would lead to much. Gardens are generous, yes, but I felt most unworthy. I was sure my manhandling of these enormous rooted plants could not possibly earn me their goodwill. But I could not have been more mistaken. I had at least timed my digging well. It was late spring, and the hostas were

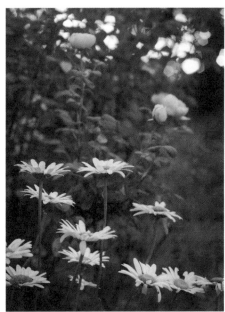
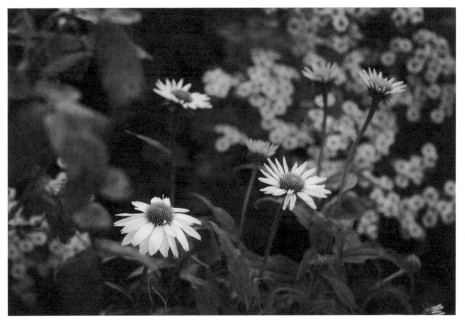

just sending their green leaves back up above the soil like cones of green parchment, ready to unroll. In other words, I could see exactly where each hosta sat, but I was not bothered with great, ungainly leaves as I dug. Not only that, but each plant had all its springtime vigor still untapped within itself. Once I had sliced them and settled them into new planting holes with a thorough drenching from my watering can, these hostas were like little green rockets all poised to blast off. Within a month, each new hosta (for I had at least tripled my hosta holdings) looked full and healthy, as if they had never been chopped up and moved at all. Miracle, I tell you.

This sort of miracle is such an ordinary part of gardening that it gives me hope. Perhaps these surprising mathematical operations don't belong to the garden only. If Galileo was right and mathematics is the language God used to write the universe, perhaps garden numbers reveal much more than garden truths. And perhaps the breaking of bread in order to multiply bread is not a *super*natural occurrence but something written into the fabric of our world. I look around for other things to divide. There are the hostas, yes, and the daylilies. There is my daily bread. There is the love I gave first to a daughter, then two sons, then broke it and grew it for one more daughter. There is money, there are minutes, there are miracles. There is—always—more than enough.

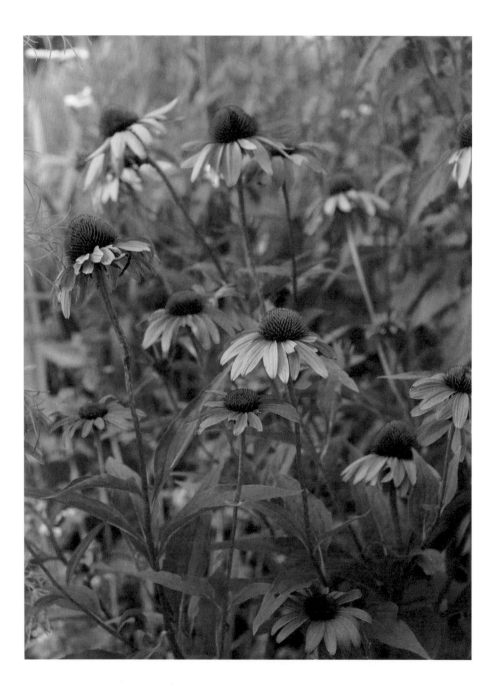

LOAVES AND FISHES

These flowers love to be multiplied through a gardener's division. In fact, they will be healthier and happier and flower better if they are divided every three to five years.

hosta

daylily

bearded iris

catmint

astilbe

daisy

black-eyed Susan

bee balm

phlox

purple coneflower

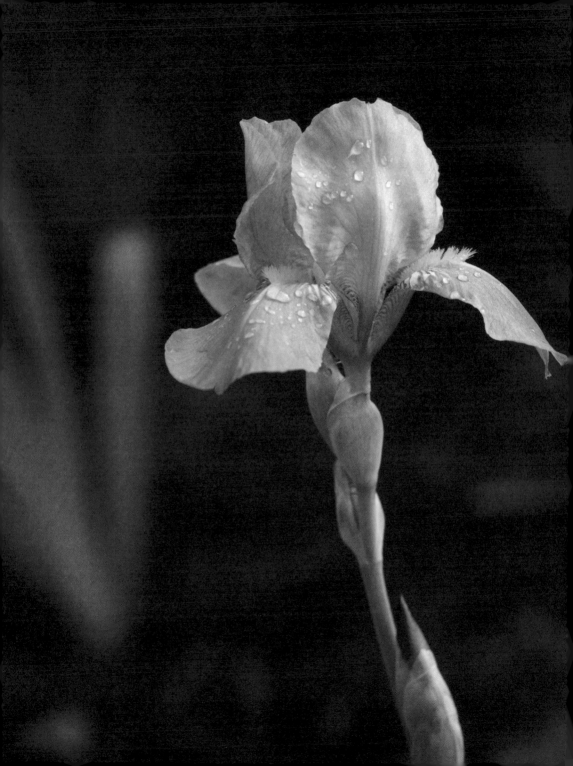

LOVE RETURNS

ONCE UPON A TIME (BEFORE SHE GREW UP, AS children are wont to do), I had a little girl. She liked to play with a long silk ribbon in rainbow colors tied to a stick. She would dance and twirl, and the rainbow ribbon would dance and twirl above her, its colors bright against the sky. This daughter was my firstborn child. I, too, am a firstborn child. I was the first of three daughters born to a mother who had been the youngest of three daughters and a grandmother who had been one of three girls. Naturally, I assumed my own daughter would have sisters, but my dancing girl was followed by two sons, one with brown eyes, the other with blue. I loved these three and assumed our family was complete, though a family without sisters in it was a strange and unfamiliar thing to me.

In Greek mythology the rainbow is personified as the goddess Iris, and Iris is the daughter of sea and sky. I suppose rainbows are often present at that meeting place of water and light, but I like to think that Iris was the child of a cloud and a white-capped wave because white holds all the colors of the spectrum. Sometimes we do not know what lives in us until we see it come to life in our daughter or our son. My second son has the blond hair

———————————|———————————

"He who said that Iris (Rainbow) was the daughter of Thaumas (Wonder) made a good genealogy."

SOCRATES

of my childhood, and I assumed it would darken as mine did. Though he is hardly a child any longer, it has not faded. It is the persistent presence of my own past, as the widow's peak on my other son's forehead is the persistent presence of my own father's face.

My father has told me many times about the scented purple iris his grandmother grew on a farm in Comanche County, Texas. That scent never left him, though my father left the farm, and the power of that scent even in memory made him a gardener, not just of hot peppers and tomatoes but of old-fashioned bearded iris and antique roses like the varieties his ancestors had carried from the East when they first came to Indian Country, as it was then called. When I moved to Maplehurst, I carried a second daughter, a fourth child, in my womb. Though she was born in September, we named her Spring. That year, I planted my first iris, bearded and purple like the ones my father remembered. I also planted a different iris. This one was white but with a hint of lavender, as if to remind us of all the rainbow colors swimming in the white. I chose this iris because unlike most of these flowers it is remontant, meaning it blooms twice in one season. This white wonder flowers in June with the other iris, and I forget about it. I assume my garden is complete until September, when my eye catches something bright in the garden again, and I realize my iris has returned.

One year on Spring's birthday, I gave her a silk rainbow. It wasn't a ribbon on a stick like the one her older sister had loved and—I can only assume—lost somewhere along the way as she grew up. This new rainbow was more like a banner. This baby sister would run with it across the grass, and it would fly out behind her. Or she would wrap it around her neck like a cape or hold it sideways like wings. She reminded me of Iris then, the messenger of the gods, the daughter of sea and sky, who used a rainbow as a road and is usually depicted with wings. My fleet rainbow daughter also

reminds me that I am too quick to say some things are ended or finished or complete. She reminds me every day that abundant life is always welling up, always returning to us, the way spring returns each year.

Every spring, my iris are so beautiful that I have never wanted to disturb them. The experts say we should dig them up and divide the rhizomes every three to five years, but my youngest child turned five, then six, then seven before I did what must be done. My older son helped. I do not often have child helpers in the garden. I am sure I offered payment. It must have been a not-too-hot day. My brown-eyed boy with his widow's peak so like his grandfather's helped me dig the white iris and the purple. He helped me inspect them for insects and rot and disease. He especially loved using my garden knife to slice the rhizomes apart like you might slice a potato.

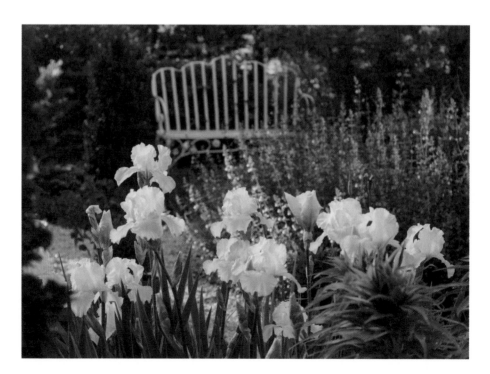

COMMON NAME: *bearded iris*

SCIENTIFIC NAME: *Iris germanica*

MY FAVORITES: *'Immortality' (a rebloomer!), 'Quaker Lady' (an heirloom), and 'Edith Wolford'*

REMEMBER: *Lovers of iris may want to grow Dutch iris, Siberian iris, and Japanese iris in addition to bearded-iris, but the growing needs for each are unique. The big, bold beauties known as bearded iris need to be planted shallow (with the tops of the rhizomes exposed) and given lots of sun.*

He helped me replant fresh and healthy rhizomes where the old patch had grown so congested.

Perhaps in another three to five years (or eight if I find myself too busy or still lacking in courage), I will divide my iris yet again and plant a new flower bed with only iris in it. Perhaps I can trade rhizomes with gardening neighbors and plant iris in every color of the rainbow. I will look for some hot and sunny spot. Though I already have iris growing amongst other flowers, it is a good idea to give iris a bed of their own. This makes it easy to dig them up and divide them when they grow too crowded, a regular occurrence since iris are among the most generous plants. Underground one rhizome grows into another and another, until generations of iris are waiting for the moment when some careful gardener will dig them up and slice them free of one another to be planted in other gardens. With help, iris are forever young and always multiplying. They return every year, some of them twice a year, carrying our memories with them, like hope-filled messages from God.

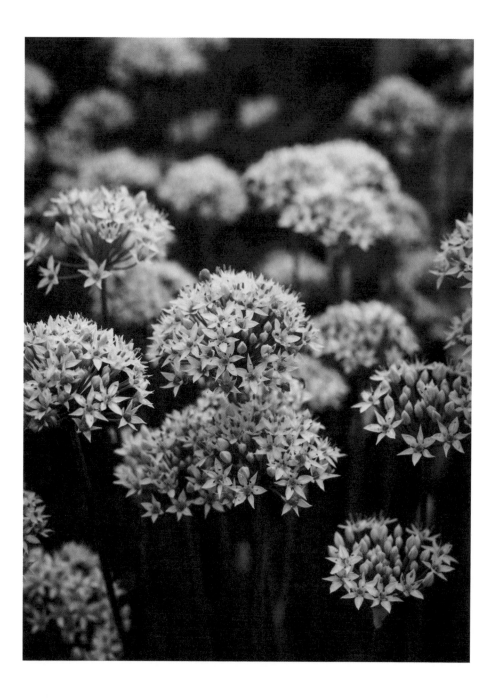

FLUFF AND FILLER AND OTHER VIPS

BABY'S BREATH HAS ACHIEVED THE UNENVIABLE position in the floral world of becoming both invisible and ubiquitous. This is a shame since who sincerely desires to give someone a bouquet in which half the flowers cannot even be appreciated? In florist speak, baby's breath is a *filler* flower. The long-stemmed red roses it traditionally complements are the *focal* flowers. Baby's breath, or *Gypsophila*, has become a floral cliché, but as it is with most clichés, this happened because the original idea was such a good one. The delicate, airy little flowers of the gypsophila plant are beautiful fresh and dry well, and their cloudlike loveliness is an ideal foil for the serious and substantial beauty of a red rose. If I had the kind of sandy, dry soil appreciated by baby's breath, I would grow it in great billowing clouds in my garden. Often, a tired cliché can easily be refreshed by plucking it out of its usual context and placing it carefully in a new one.

Alas, the soil here at Maplehurst is not baby's breath-friendly. I garden on heavy, wet clay, and gypsophila would quickly develop root rot. But the florist-approved combination of focal flowers with filler flowers is a

"Only connect! That was her whole sermon. Only connect the prose and the passion, and both will be exalted."

E.M. FORSTER, *HOWARDS END*

pairing worth applying to our gardens too. I may not grow baby's breath beneath my roses, but I can grow the tiny flowers of sweet-scented alyssum. And I can grow forget-me-nots and Johnny-jump-ups in spring. Even flowering herbs like oregano or basil make wonderful filler, both in the vase and in the garden. And there is certainly nothing clichéd about an edible arrangement that has nothing to do with chocolate-covered strawberries or melon cut into flower shapes.

While *filler* is the appropriate florist term, the most relevant garden term is probably *groundcover*. Groundcover plants do exactly what their name implies—cover bare soil—but since most garden flowers are viewed from above, plants that cover the ground can perform double duty as a backdrop and a foil for focal flowers like roses or dahlias. Many varieties of roses, in particular, are known for their "bare knees," a term I have often encountered in my gardening books that never fails to make me smile. If the rose is the queen of the garden, we must not shame her by leaving those naked lower canes without some sort of frilly cover. Catmint, being taller than alyssum, does this job very well.

These are the unsung heroes of the garden. We call them fluff and filler, but without them every garden would be a jumble of disconnected puzzle pieces. "Only connect," the novelist E.M. Forster wrote so famously in his novel *Howards End,* and these are the plants that do that so well. No wonder we sometimes forget to really look at them. When they do their job effectively, we see the beautiful rose or we see the beautiful garden, but our eye is not drawn to the froth of white or purple that leads our gaze from rose to rose while weaving everything together. But the garden maker must never forget to look. For gardeners cannot plant what gardeners have never noticed.

Of course, *filler* does not have to imply *flower*. Some plants, like the dark purple-leaved types of dahlia, act as their own complete bouquet, with each flower set like a jewel against its leafy backdrop. Sometimes it is the shape or the texture of a plant that sets off a flower well. The colorful foliage of heuchera, the feathers and fronds of ornamental grasses, or the bold tropical leaves of a hosta can bring an arrangement or a border to vivid, brilliant life. The key for the gardener is to pay attention to the in-between. Is it empty, showing only soil or mulch or the blank blue sky? Is it filled but distracting, vying for attention and creating chaos for the eye? The gardener's first task may be to choose a beautiful tulip for spring, but her second is to recognize that no tulip looks its best against a backdrop of wood chips. What can we place there instead? It need not be a spring bloomer, though forget-me-nots would be wonderful. It might surprisingly be a perennial that will look its best in fall, like sedum. Even sedum, which grabs our attention only late in the season, begins growing in spring. I think the chartreuse foliage of newly emerging sedum would veil the bare knees of the tulips beautifully. And which one, would we then say, is the real VIP (Very Important Plant)?

ANTICIPATE

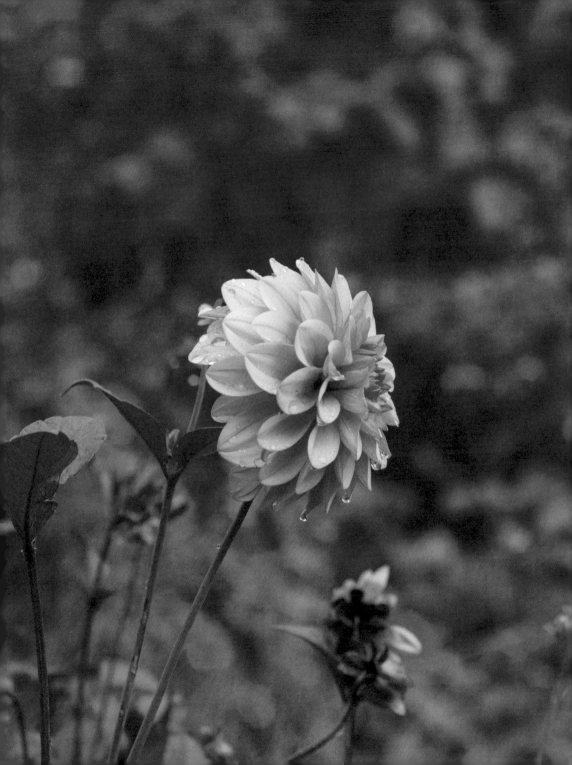

STORY MAKER

IT IS STRANGE THE THINGS WE BELIEVE WHEN we have not really taken the time to look closely. For years I thought I knew what autumn was—the brown and gold season of losing, letting go, fading, dying (though brilliantly so). Then I became a gardener. It turns out autumn is also like a second spring. Not only do the roses come alive again, blooming in flushes despite their yellow-spotted leaves, but so many plants come into flower for the first time—colorful dahlias, for instance, Japanese anemone, the ornamental grasses. There are also the berries, like the red or orange of winterberry shrubs, and the hips on the wild roses. I don't suppose I was wrong before in my view of this season. Rather, I knew only one-half of the story. And half of any story is not much good to us, is it?

The earth itself tells a good and true story through its shifting seasons. And this ancient and enduring story of spring, summer, fall, and winter is itself woven into numberless other tales. It is an archetype, a recurring motif that has yet to lose an ounce of its power and meaning. When we make a garden, we are also creating a story, and every garden story we write is rooted in the deep story of God's creation—a story of birth, growth, maturity, death, and resurrection or return. It may be that every

"The story-maker proves a successful 'sub-creator'. He makes a Secondary World which your mind can enter."

J.R.R. TOLKIEN, "ON FAIRY-STORIES"

true story—no matter how small—spreads its roots in this creation story, as if it were possible to embroider stories with other stories, the way every one of my rosebushes is embroidered with dewy webs when I go out on some October morning.

Some of these more diminutive stories almost seem to tug against the limbs of the primary narrative. For instance, spring is traditionally understood to be the season for planting seeds, but then every gardener knows that seeds are also always sown in fall. The dried flowers of my zinnias and cosmos are dropping seeds upon cooling soil even now, and no doubt some of them will return as new plants next year. Autumn is also the time for planting bulbs. There will be no spring daffodils or tulips or crocuses if some hand (or industrious squirrel!) has not first planted them in fall. Is autumn, then, a story of birth? Death? Or both?

And what story do my dahlias tell? They are at their very best on the eve of disaster. They will be cut right down by the first hard frost, toppled mercilessly by a cold but unseen hand. Why then do they seem to save their showiest flowers for the cool nights that come just before the crisis? They flirt with danger, these dahlias. They also make the most of the time they have, and they give me something to anticipate. As long as the garden is still growing, as long as that first freeze has not yet come, I yet have something to look forward to, something like a water lily, or a pom-pom, or a great, ruffled dinnerplate. And as I am the maker of this garden, I also shape this dahlia story. When I plant the orange dahlia 'David Howard', I nudge the story in the direction of brilliant fall. When I plant the blushing beauty 'Café au Lait', I tell a fresh springtime story in September.

Of course, we gardeners also tell accidental stories. Hardly thinking about it, I planted some extra Mexican sunflower (*Tithonia*) seedlings in an empty bed between house and barn where next year I intend to plant grasses.

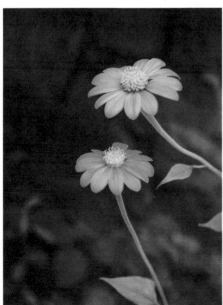

In July, the tithonia seemed a part of the general summer brilliance, but now in late October, their orange matches the orange of the crape myrtle leaves and reflects the glow of the golden-leaved silver maples in the woods beyond our fence line. They have intensified the general autumn story in a way I did not predict when I tucked small seeds into the soil in May.

Dahlias can be fussy plants, and they frequently drive me to distraction, bending and breaking as they are wont to do. But by blooming fiercely and gorgeously on the very cliff edge between life and death, they tell a story I simply must have in my garden. Every year they tell me that even when we stand at death's door, we have not reached the end. We still have reason to anticipate . . . more. And that may be the best and truest story our gardens tell. There is no end in a garden. Everything—even death—is a return to life.

In the autumn, I enjoy the way the Japanese anemones flutter in the slightest breeze on their tall stems. It is for good reason they are also called windflowers. And in the autumn, I add fallen leaves, well-chopped with the lawn mower by my husband or son, to our compost pile. Dead leaves are such life-giving food for gardens that I am tempted to go out into the surrounding streets, gathering up the bagged leaves my neighbors have left on their curbs. I already have a great deal of dead leaves to deal with each year at Maplehurst, but the more abundant the garden, the hungrier it is. No fallen leaf is ever wasted here.

In autumn, before the garden has gone entirely to sleep, I look back and I dream ahead. What stories have I told in my garden this year? I was sure of the orange and purple tulips I ordered in spring, but will I be so sure when they come up next year? Do I really want to tell a royal jewel-toned tale in the border beneath the kitchen windows? Well, no matter. I am planting the bulbs this week. Even if this is a story I decide to tell only once, so many other, more perennial stories return every year. Some I have written,

and some I only read. I cannot wait to greet all that returns. I will wander about as if lost in a good book, telling anyone who will listen, "Oh, look! See there? I love this part."

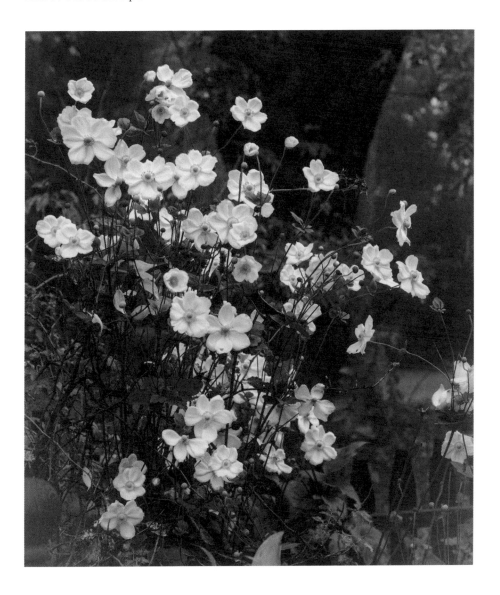

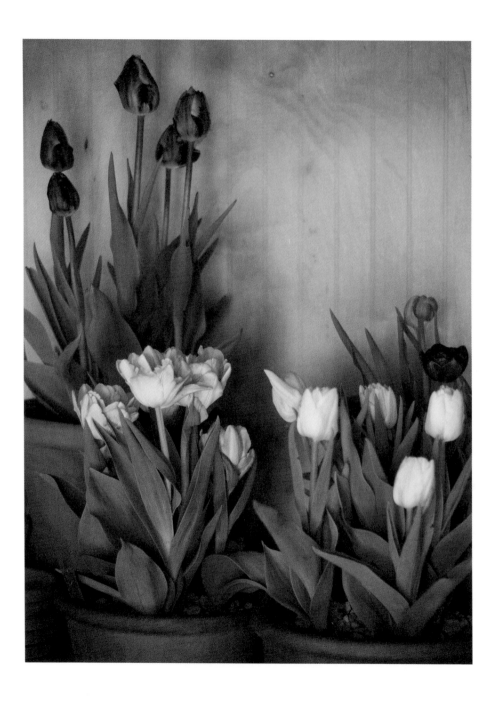

PUTTING THE GARDEN TO BED

Here are the chores I always hope to tackle before the snow flies:

— Plant spring-flowering bulbs in the ground and in containers.

— Move my potted perennials (for instance, boxwood and roses) into the garden shed or some other sheltered spot.

— Scrub out the pots and containers I used for summer annuals and store them for next year.

— Clear out the raised beds of my cutting and vegetable gardens.

— Chop up fallen leaves with the lawn mower to use as mulch on raised beds and borders.

— Clean and care for my tools and store for winter (full disclosure: I have never yet ticked this item off my list before spring, but a gardener can dream).

— Leave most garden cleanup (with the exception of peony foliage that can harbor disease) for late winter or very early spring; dried stems and seedheads are lovely to see all winter, provide food and shelter for wildlife, and even protect the roots of my perennials from the harsh freeze-thaw cycles of winter.

— Beginning December 26, check the mailbox daily for new seed and plant catalogs.

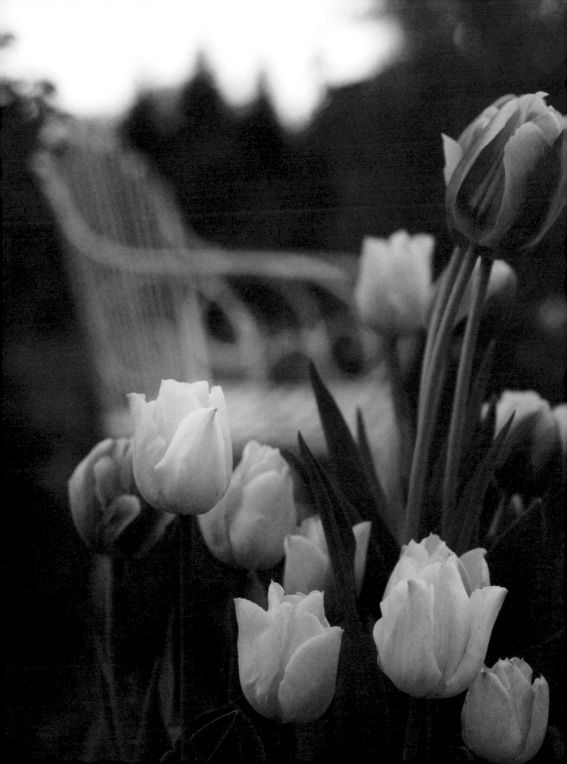

TULIPS

The Now and the Not Yet

EARLY NOVEMBER IS TULIP SEASON HERE AT Maplehurst. There are no tulips to be seen, of course, but seasons are made up of the seen and the unseen. It is these unseen tulips that nudge me out of doors despite the cold bite in the wind. While I haul a heavy crate filled with papery bulbs and scrub out terra-cotta pots that I wish I'd cleaned before the water from the outdoor tap became quite so icy cold, I try to picture the spring colors. Should I plant only a single variety of tulip in each pot? Was I right to order purple and orange tulips for this bed by the kitchen door? Purple and orange are lovely in summer, but I wonder if they are quite right for spring. Perhaps they need strong, hot sunshine to look their best.

Tulips are pure color for our gardens. They give us our best chance to garden like painters, spreading drifts of a single color across the canvas of our borders and pots. My love for tulips today seems linked with my childhood love for brand-new Crayolas in a neat yellow box. I'm sure I spent almost as much time admiring the sharp new points and smooth, waxy colors of my crayons as I spent using them to draw—what else?—pictures of red tulips springing up from a line of green grass beneath a yellow smiley-face sun.

"The kingdom of heaven is like treasure hidden in a field."

MATTHEW 13:44

I choose different types of tulips for different uses. For instance, I grow fancy doubles, parrot types, and fringed tulips like the variety 'Mascotte' only in pots or in my cutting garden. I prefer tall, elegant lily-flowering types in my borders. But my primary choices all revolve around color. Thanks to tulips, my spring garden is the most color-controlled garden I have all year. As color slowly leaches from the landscape throughout the month of November, I am confronted by a canvas that seems to grow blanker every day. I study it and ask myself whether next May I will want a crisp, cool garden in green and white. If so, I will fill my flower garden with a hundred or more 'White Triumphator'. Or, after a long winter, will I be craving more color? Perhaps I can weave in the cool, striped pink of 'Ollioules', a tulip I especially love because it is more perennial than most. Of course, I must not forget to paint the shadows. Tall, regal, and almost black, *Tulipa* 'Queen of Night' is ideal for this.

These color choices also matter to me because these will be the shades of anticipation I lean into all winter long. The thread that links the moment I bury a bulb in November with the moment I first spy its pointed green leaves in April is always a colored thread. I am not waiting for green. I am waiting for white, pink, purple, and orange. I am waiting for solid scoops of pure color, and I am waiting for the "broken" streaks and stripes of Rembrandt tulips that look as if they've just fallen out of an old Dutch-painted masterpiece. In autumn, my garden is a paint-by-number canvas, but the result of my care and my choices won't be visible until spring. This is the sturdiest, most solid thread of anticipation in my whole life. It ties every autumn with every spring, and it has become a path through winter strong enough to guide me on even the dreariest and most gray of days. Tulips once inspired mania, but they have given me sanity and stability. I can more easily hold on to equanimity in winter if I have planted tulips in the fall.

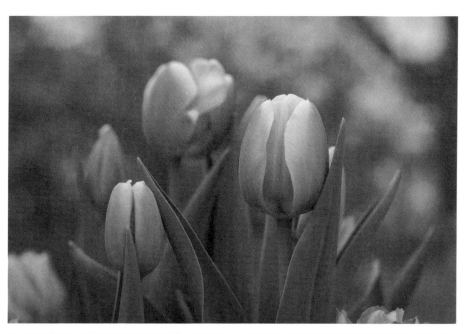

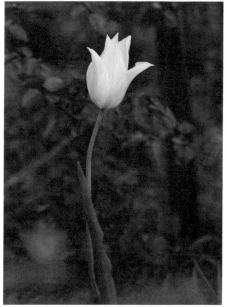

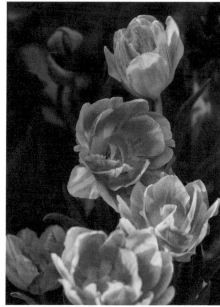

COMMON NAME: *tulip* | **SCIENTIFIC NAME:** *Tulipa*

MY FAVORITES: *'White Triumphator', 'Ollioules', 'Dream Touch', and 'Queen of Night'*

REASONS TO LOVE TULIPS: *They are like a box of crayons for the garden maker.*

REMEMBER: *Tulip bulbs must be planted in fall to flower in spring. Some varieties are perennial, but most bloom their best only in their first year. I plant fresh tulip bulbs each year for the best display.*

Tulips are Now and they are Not Yet. They are fully present on this cold autumn day; holding a tulip bulb the size of a small head of garlic in my hand, I know I am holding all of it. And yet only hope and faith born of experience could ever connect this papery package with the tall, straight stem and curved petals of a lily-shaped wonder like 'Blushing Beauty'. In this way, tulips are like that kingdom which we know came with Jesus of Nazareth but which is also every day *coming* and which will one day fully and finally arrive. Why must it take so long? Perhaps there is purpose in these millennia of waiting just as there is purpose for the winter waiting of the bulb. Tulips cannot grow without winter cold. When the temperature of the soil drops below 55 degrees, a biochemical process is triggered inside of it. Stored starches and carbohydrates are transformed into glucose. After 12 to 14 weeks of cold, the bulb has enough converted energy to flower. The waiting of winter is never as empty nor as unproductive as it appears to be.

I once used my crayons to draw maps that would lead my sisters to backyard treasure. Now bulbs are my buried treasure and a reminder of that pearl of great price of which Jesus spoke. Because they are precious, I do not grow them out in the lawn, as I do with the daffodils and crocus. They are rarely strong enough to push through turf anyhow. And I do not plant them at a distance from the house. Squirrels and deer will find them there, and tulips are deer food, as delectable to them as the first fresh spears of asparagus are to me. I plant them in borders quite close to the house where deer tend not to browse. And especially I plant them in containers. This means they are safe from the busy digging hands of squirrels in winter because I keep the pots in my cold garden shed. And this means I can move them around in spring to make the most of their brilliant color.

Planting in pots is easy enough to do. I prefer natural terra-cotta, and I am careful to lighten up my heavy bagged potting soil with some combination of sand or horticultural grit and vermiculite. Bulbs don't like to sit in boggy dirt. I pack the bulbs into a bed of soil—not quite touching—then cover with more soil and a final layer of pebbles. I give the whole thing a good watering, and then I ignore the bulbs in the shed until I see the first white-green tips. Then I water them well again. Now my waiting is almost finished, and my joy is so nearly complete.

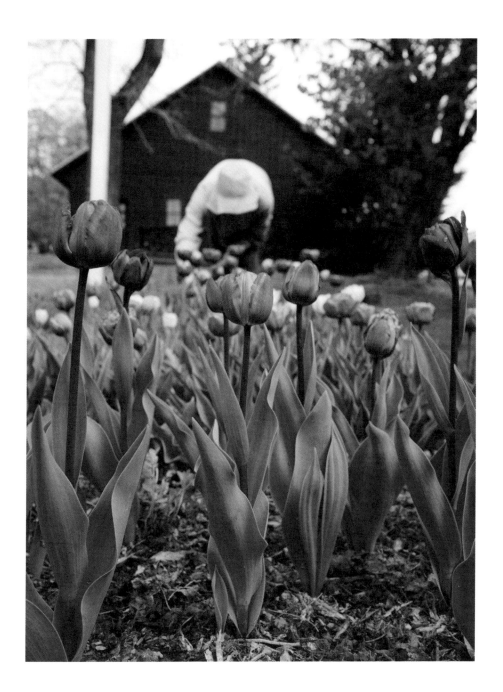

NEXT YEAR

I LIKE CRYSTAL RIVERS AND CLEAR EMOTIONS.
I like sweet flowers and simple moods. But at the end of the growing year, my feelings about the garden are as muddied as the fallen leaves of the sassafras scattered around our black barn. In late fall, I want to hold on, *and* I long to let go.

All at once it seems I am tired and ready to put every last bit of the garden to bed for the winter. Yet I am also already grieving the loss of fresh-cut roses, vine-ripened tomatoes, and perfumed basil that I would sometimes throw in a vase and other times toss on a pizza. There is no escaping my sure knowledge of just how much I will miss these gifts of the garden. I know from experience I will feel their absence so severely that by March I will struggle to believe in spring at all.

Are there any goodbyes that are not bittersweet? In such moments, we need language to comfort us as well as nudge us in the right direction, and there is no more comforting, encouraging phrase in a garden maker's lexicon than *next year*. "Next year," we say, "won't this rose be tall and beautiful? Next year, won't we weed with diligence so our garden never grows out of control? Next year, won't we water our pots daily and fill them with

"It is possible that God says every morning, 'Do it again' to the sun; and every evening, 'Do it again' to the moon. It may not be automatic necessity that makes all daisies alike; it may be that God makes every daisy separately, but has never got tired of making them."

G.K. CHESTERTON, *ORTHODOXY*

dahlias again—those did so well this year blooming from May to nearly November—but perhaps a wine color rather than this year's salmon-pink?"

Next year is a phrase full of hope and commitment. These words help us let go of this year's garden and turn our faces toward the next. Because even when we are tired, even when months in the garden have led us to anticipate winter ice and snow as a kind of rest and reprieve, even then we look forward to the day when we will witness our garden unfurling itself all over again. How we long to greet our daffodils or our peonies or that particular fence smothered in a 'White-Eyed Susie' vine; they have been our dear friends these many months, but we also long for a new spring-fresh garden. Just like gardeners, this year's garden has grown tired and old. "Do it again!" we will say joyfully to our garden next spring, followed by the words, "and better."

Year after year, gardens pull off an almost miraculous high wire act. They are new every spring while also becoming more mature, what we gardeners call *well established*. A 20-year-old garden in spring is like a newborn baby simply bursting with energy to grow, but it is an infant with an old soul. Ancient wisdom is stored up in roots that have been spreading unseen for years. Unlike a newly planted space, this garden cannot be easily destroyed by winter cold or wild weeds. For many trees, shrubs, and herbaceous perennials—like peonies—all we see the first year is promise. I planted young gum trees this year (*Nyssa sylvatica* 'Green Gables'), and I know one day they will look like pillars of fire on either side of the porch in fall. This year, they are more like red lollipops, but they will grow. Last spring, I also planted three bare-root specimens of the David Austin rose 'Olivia Rose Austin'. These new shrubs never reached higher than 18 inches, but they did show off some lovely pink flowers. Having grown this rose in the past, however, I know that by next year, or perhaps the year

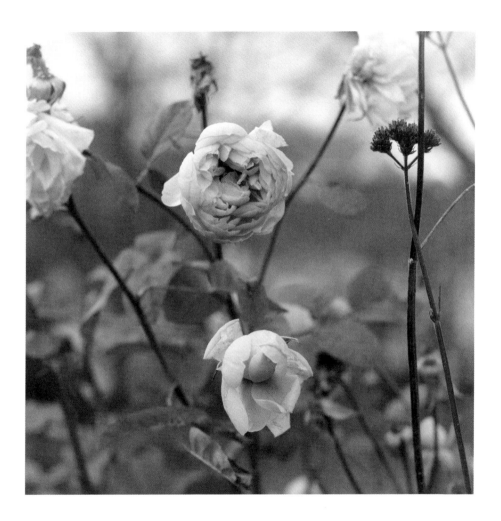

after, they will be four feet tall at least. They will be sweetly new, and they will be wonderfully old.

The writer G.K. Chesterton describes creation not as robotic and monotonous in its daily and seasonal rhythms but as constantly renewed by an always active Creator: "It may be that He [God] has the eternal appetite of infancy; for we have sinned and grown old, and our Father is younger than we." That is a good description of how I feel as a gardener each autumn. I have grown old and tired and only spring can revive me. On the eve of the first hard frost, my garden sins are everywhere apparent. I never did rescue the pink windflowers and green ferns from encroaching knotgrass. The autumn yellow of this bamboo-like weed is a splash of color as loud as a disapproving voice on the edge of my back garden. And I did not give any of my dahlias the strong support I promised myself I would when I planted the tubers last spring. I can see how some of the heavy stems of the dinnerplate dahlia 'Café au Lait' have broken. I have harvested many beautiful flowers, but with care I could have grown many more. I am eager now for snow because I am eager for rest but also because I want these sins erased from sight.

A garden submits to the limits and boundaries of a good creation, for neither human strength nor summer warmth is unending. Yet each can be and will be renewed. The psalmist sings of a God who satisfies our desires with good things so our "youth is renewed like the eagle's" (Psalm 103:5). I do not know much about eagles, but I know my own youth is renewed every year when I spy the first white snowdrop pushing through the snow. Like the ones who make them, gardens grow and gardens rest. Gardens are never finished. All year long, they sing of God's promises and plans for us. They sing of our hope and of our future.

ABOUT THE
AUTHOR

CHRISTIE PURIFOY IS A WRITER AND GARDENER who loves to grow flowers and community. She is the author of two memoirs, *Roots and Sky: A Journey Home in Four Seasons* and *Placemaker: Cultivating Places of Comfort, Beauty, and Peace.*

Christie earned a PhD in English literature from the University of Chicago but eventually traded the classroom for an old Pennsylvania farmhouse called Maplehurst where, along with her husband and four children, she welcomes frequent guests to the Maplehurst Black Barn.

BLACK BARN
GARDEN CLUB

WHETHER YOU ARE AN ASPIRING GARDENER OR an experienced one, Christie would love to welcome you into the Black Barn Garden Club, an online membership community committed to cultivating wonder, at www.blackbarngardenclub.com. You can also learn more about Christie at her website, www.christiepurifoy.com, or connect with her and discover more about life at Maplehurst on Instagram @christiepurifoy and @maplehurstgardens.

With her longtime friend and fellow writer Lisa-Jo Baker, Christie hosts the *Out of the Ordinary Books* podcast for storytelling and conversation inspired by some of the many books on their bookshelves. New episodes are shared each Wednesday.

Together, Christie and Lisa-Jo and a community known as the Black Barn Collective turn social media's usual ways upside down through quiet, weekly rhythms of listening, sharing, and celebrating in a virtual gathering place called the Black Barn Online. You are invited to join them at www.blackbarnonline.com and help tend a space where art and faith cultivated in community take root, flourish, and grow.

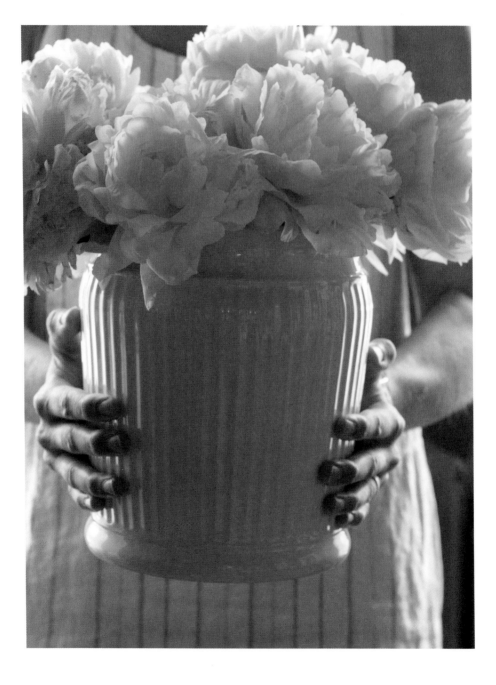

ACKNOWLEDGMENTS

MY FIRST THANK-YOU MUST GO TO MY HUSBAND, Jonathan, who supports my garden making with love and enthusiasm and also digs the holes for all of the trees and shrubs I choose. My second must go to my father, Mark, who made the garden that will always be the enchanted backdrop to my childhood. My third is for my sister, Kelli, who told me to buy a packet of zinnia seeds. And my fourth is for my agent, Bill, who, when he asked if I would consider writing a gardening book, lit a fresh, creative spark in me.

Thank you as well to my friend Lisa-Jo for guiding me toward the just-right cover photo, and thank you to my children, who are patient with me, who pose for me in the garden, and who sometimes tap the shutter button on the camera when my own hands are covered in dirt.

Cover and interior design by Faceout Studio.

Graphics on pages 27, 59, and 193 © R. Wilairat / Shutterstock; pages
33 and 104 © lisima / Shutterstock; page 74 © Anastalsiia Nastyna /
Shutterstock; page 97 © Alina Linum / Shutterstock;
page 122 © Svetlana Striukova / Shutterstock; page 132 © maritime_m
/ Shutterstock; page 171 © Olga Alekseenko / Shutterstock; Some design
elements © olga.korneeva / Creative Market

GARDEN MAKER

Text and photographs copyright © 2022 by Christie Purifoy
Published by Harvest House Publishers
Eugene, Oregon 97408
www.harvesthousepublishers.com

ISBN 978-0-7369-8214-6 (hardcover)
ISBN 978-0-7369-8215-3 (eBook)

Library of Congress Control Number: 2021941726

Printed in China

21 22 23 24 25 26 27 28 29 / RDS–FO / 10 9 8 7 6 5 4 3 2 1